# *Dürer*

## The Great Draughtsmen

# Dürer

Hans Hoetink

Pall Mall Press  London

Dürer
*Translated by Noël Lindsay*

*General Editor*
Henri Scrépel
*Originally published in French under the title*
l'Univers de Dürer, *in the series* Les Carnets de Dessins

*Copyright © 1971 by Henri Scrépel, Paris*

*Pall Mall Press Ltd.,*
*5 Cromwell Place, London SW7*
*First published in Great Britain in 1971*
*All rights reserved*
*ISBN 0 269 02794 7*

*Printed in France*

*Dürer*

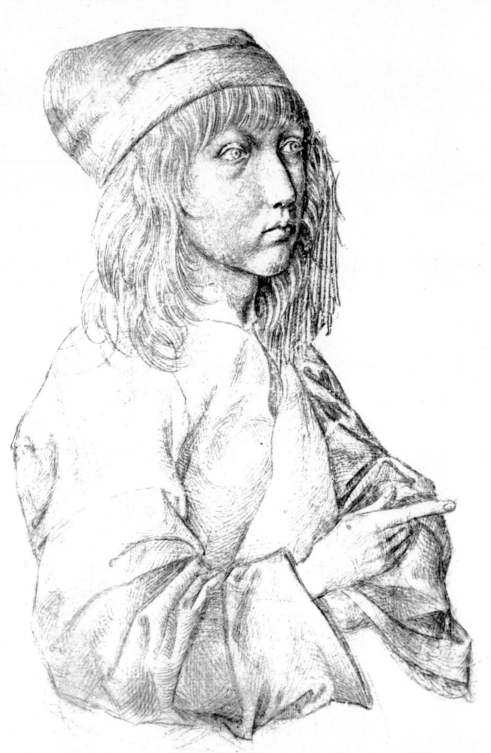

Self portrait as a child (1484)
Silverpoint

Albertina Museum, Vienna

# Contents

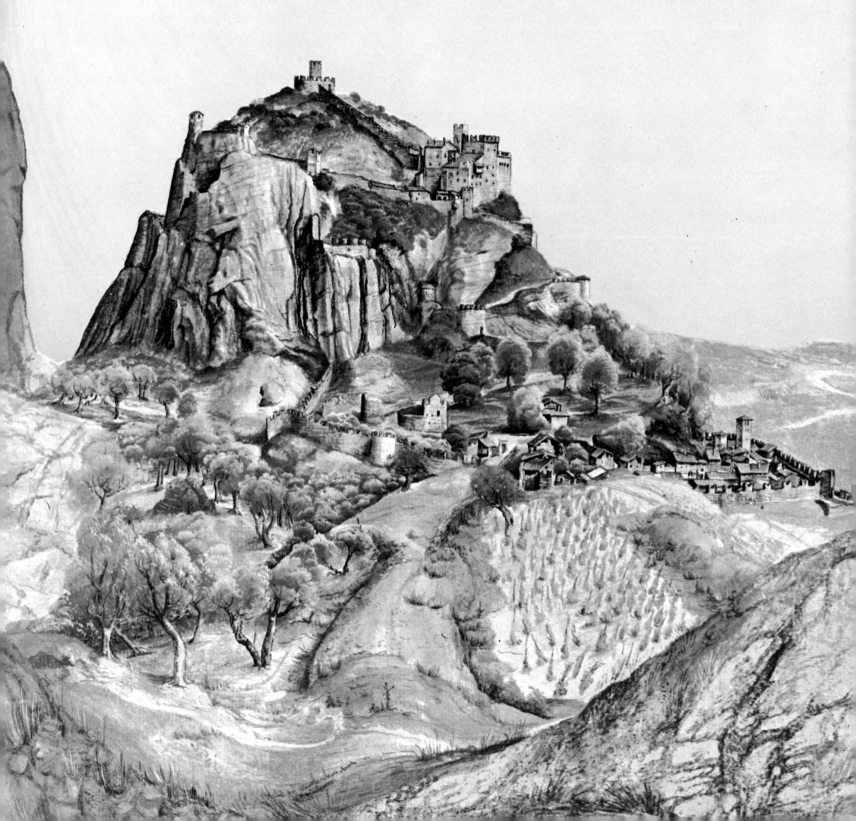
*fenedier klouser*

# Dürer, the Creator of a new Reality

Can anything be more fascinating than to witness the appearance, at the hands of an artist of genius, of that new flame which sheds a fresh light on the familiar face of the past?

The way in which they reconcile their personal message with inherited culture, the way in which they take hold of tradition and forge it into an instrument of progress, seems to be one of the characteristic features of great men. The problem is not one for the artist alone, but for all of us, at least if we desire to take an authentic place in the world around us.

Thus, Dürer, seizing hold of original emotion, in all its primitive freshness, gives it form within the strict framework of tradition, which is certainly a limitation, but in no way an insuperable obstacle.

Medieval traditions still weighed heavily on Germany at the end of the fifteenth century at the same time that new impulses were coming to birth and new standards were beginning to take shape. This was the age in which the young Albrecht grew up, an age very like our own, of rapid and violent social, religious, political and artistic change. It was an age in which it was not easy for a man to find his proper place.

Around 1500 three great figures, Luther, Erasmus and Dürer very largely shaped the cultural destiny of Northern Europe.

All three were intensely conscious of the value and the dangers inherent in the medieval tradition and in the spirit of their age; all three felt that they had a mission to fulfil in the world. In spite of all obstacles, the future lies open to man and it always involves, in addition to the heritage of the past, an element of novelty which escapes all law. This new element, due to man's initiative, finally creates a new historical fact, unpredictable because it is the result of a creative act.

Luther's mission was to give an independent form and a new content to the Christian faith. Furthermore, the use which he made of his native tongue has left an imprint on German religion and German language which can still be detected today.

The contribution of Erasmus was a new way of thought. His conception of the freedom of the individual, as *homo pro se*, and not governed by the community or by his "commitment", has an astonishingly modern ring.

Arco (1495)   Watercolour and gouache
Louvre, Paris

For Dürer, it was a renewed and deep love of nature and of man, generating a new outlook which, in its turn, creates a "new reality". It is in his drawings that it is most clearly expressed.

This "new reality" can be created only by the most independent and the most exceptional spirits among poets, artists, thinkers and the founders of new religions. It is they who blaze the trail for us in the art of seeing and thinking.

The true creator is the artist, not because he leaves us a work of art — poem, drawing or painting — but because in that work of art he gives us a new interpretation of the world which surrounds him, thus creating a new reality.

It is in this way that Dürer guides the outlook of his contemporaries and of the generations of artists after him.

Basing himself on the past, he thus proves to be one of the founders of our present view of life, and in this his work remains profoundly modern. Without him — and this is a feature which he has in common with all great artists — our inward world would bear a different aspect.

Dürer lived in the first quarter of the sixteenth century, a century overflowing with new ideas and new discoveries, in which the boundaries of human knowledge were being constantly enlarged. New worlds are discovered, the secrets of the human body are unveiled, printing disseminates ideas on empirical knowledge which still determine the way we look at things today and which were to become the starting point of modern scientific research.

The Bible, too, is studied and interpreted anew, while the first serious textual criticisms and consultation of archives begin to appear. In philosophy, medieval scholasticism comes to an end, and in politics we can see the first dawn of modern states.

There were few who escaped the profound emotion aroused by the appearance of new ideas in Europe between 1480 and 1530. This period was also that of the blossoming of German art.

Flanked on the one side by the old Martin Schongauer, still Gothic, and on the other by his junior, Hans Holbein, deeply steeped in the ideals of the Renaissance, Dürer is the central figure of this time.

There are more than simple relations of cause and effect between the cultural phenomena of a given age and the manifestations which appear in other fields.

The first thirty years of Dürer's life still lie in the fifteenth century, and his contemporaries are more sensitive to the spiritual heritage of the Middle Ages than to the attractions of the new times. And yet the chosen spirits already very clearly felt that they were living in an evolving world. In company with Erasmus, Thomas More, Dolet, Budé, Melanchthon and many others, Dürer was convinced that the "obscurity of the Middle Ages" had been left behind him.

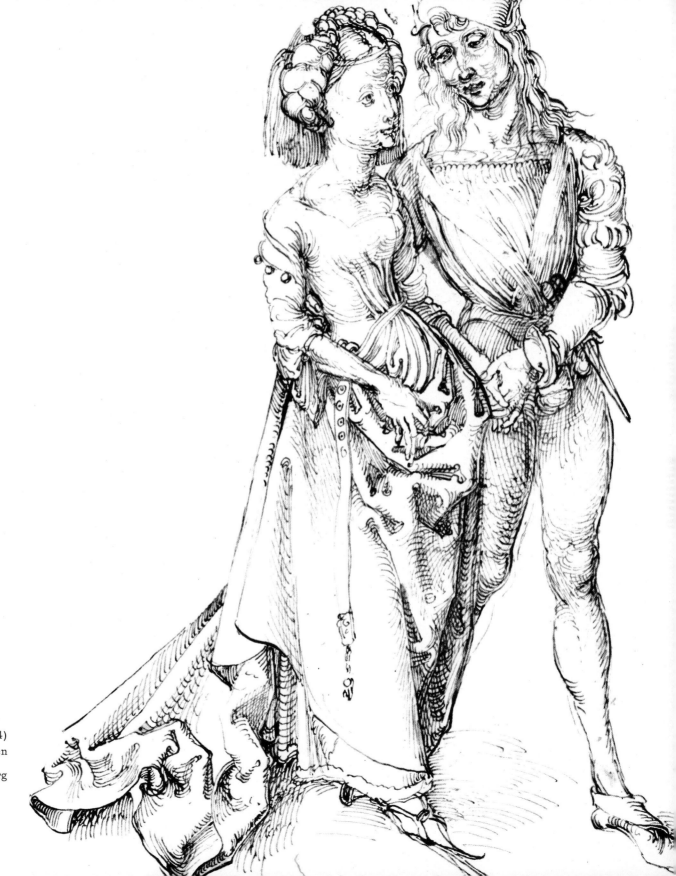

A young couple (1484-1494)
Pen

Kunsthalle, Hamburg

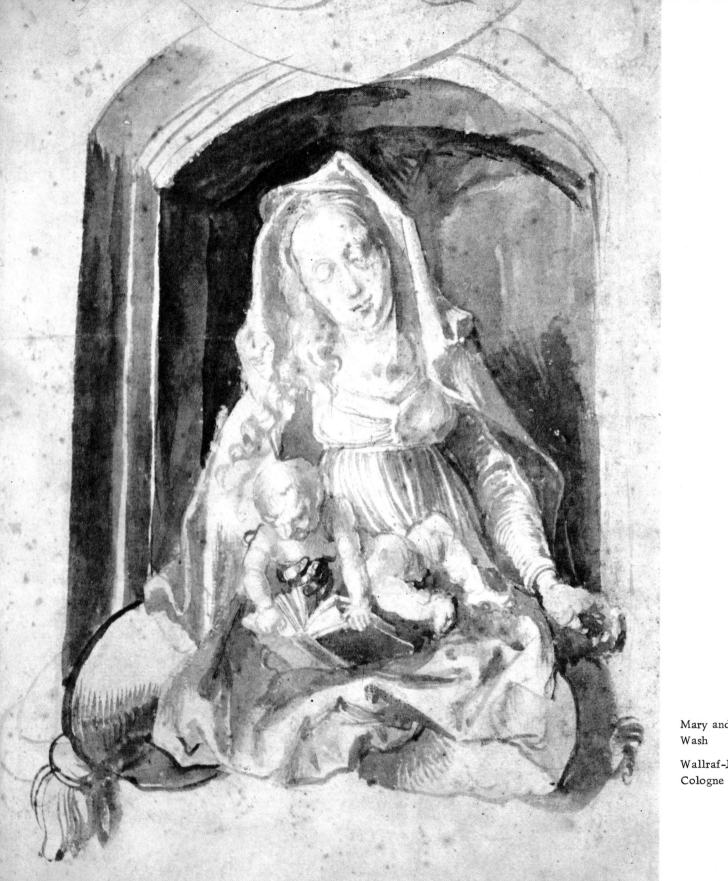

Mary and Jesus (1495-1499)
Wash

Wallraf-Richartz-Museum
Cologne

When intellectual life is influenced by new circumstances, the main feeling aroused is that of confusion, anguish and insecurity, owing to the disappearance of old standards and conceptions. From many points of view, a parallel may justly be drawn between the 1500s and our own day.

This gives Dürer's work a special interest for us: Dürer, the author of the engravings of the *Apocalypse* (1498), which dramatically evoke the social and religious climate of the time; Dürer, the creator of the celebrated *Melancolia* (engraving, 1514), an unparallelled expression of human inadequacy; Dürer, the draughtsman of a "dream image" which reminds us of the most sombre menaces of our own day.

More than the attraction so visibly felt by Dürer for the events of his time — evident in his works and his writings — what finally interests us is their artistic content.

Dürer's greatness lies in the fact that he is one of the rare creative spirits capable, by the contribution of new and original forms, of consciously filling the gaps which became apparent during his time; and it is certainly through his drawings that we can best follow the heroic combat which he joins. He had to merge together elements such as sensitivity and realism, measured harmony and the sense of the monumental, the feeling for nature — dear to the end of the Middle Ages — and what is apparently so opposed to it, the love of detail and of ornament, still so dominant in the artist's work.

Dürer must have felt intensely this rivalry between the Northern tradition and the forms of the Italian Renaissance. It can, moreover, be followed like Ariadne's thread throughout the evolution of German art right up to the nineteenth century. That is why Wölfflin could write that "Dürer introduced the great uncertainty into German art".

Erasmus succeeded in merging the Christian world and the classical humanist world and Dürer finally gave plastic form to this ideal; he presented to his native city, as a profession of faith, his last painting, known as *The Four Apostles* (1526).

In it he creates the image of a Christian humanism which has remained for four and a half centuries, the essence of what Europeans understand by civilization.

These forms which we still admire today are the result of his ethical and religious comprehension of the world.

Dürer's need for knowledge and his search for a principle of harmony must be looked at in the light of the problem which always preoccupied him; how to penetrate the divine sense of the world and of life and to give them form. The fact that he was increasingly able to give material form to his theories over the course of years shows his intellectual courage and his mastery of matter. Dürer, who was a better judge of art than anyone, simply confessed: "Beauty, what is it, I cannot tell!" That is the touchstone of his greatness.

# "Born to See, Destined to Contemplate"

The chant inspired by Goethe's Faust might have been written for Dürer. From his earliest youth he was possessed by a thirst for seeing which we can hardly imagine today. Inundated every day by a "wave of images", by newspapers, reviews, films and television, nothing is more natural for us than to look at the external world and reproduce it. But do we really look? Can we still look in the same way that Dürer looked? He looked at the world with a new vision, thrusting aside the Gothic heritage so deeply rooted in the German past. We constantly find in him an intense curiosity about nature, its riches and its innumerable details. The freshness with which he sets down in his drawings what he has just seen, and which still affects us so keenly today, might be called *Sinnlichkeit der Anschauung*, sensitivity of perception. Whatever the subject, a landscape or a portrait, a seated Virgin, a plant or a dead bird, hands, a nude, we always find the same intense attention to reality. We are struck, from his very first works, by the purely objective, perhaps sometimes even too cold, quality of his observation. He scarcely ever yields to the temptation to strain reality for the sake of expression, as, for example, his contemporary Grünewald does, whom he must have met at Aachen or Cologne. It is only in his so expressive use of colours in some of his first watercolour landscapes or in the touching portrait of his mother, or in the famous drawing *Death on horseback* that we perceive a different inspiration.

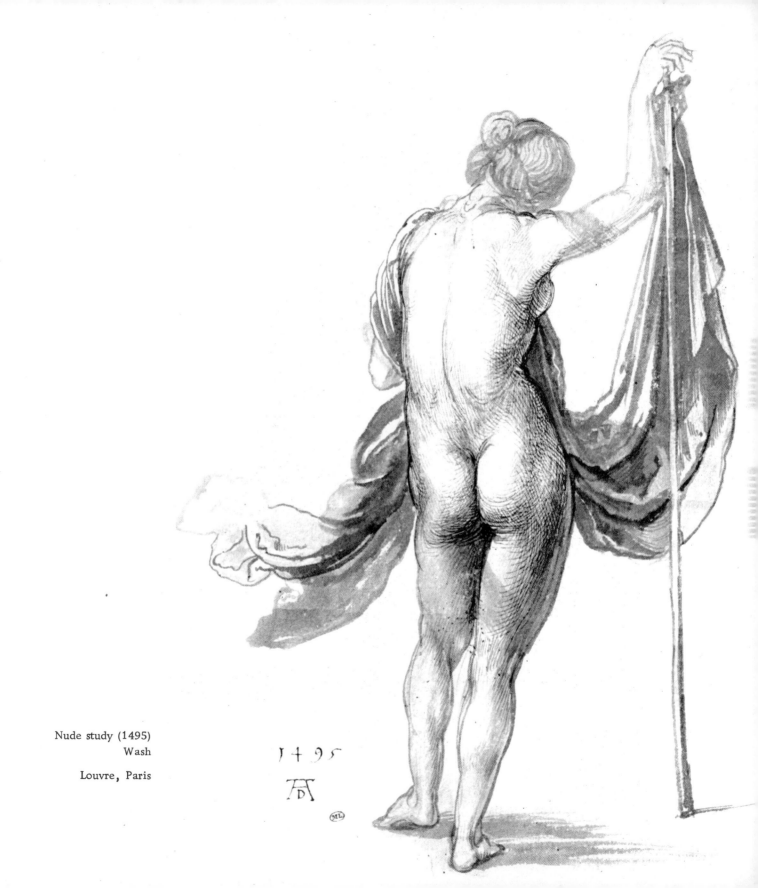

Nude study (1495)
Wash

Louvre, Paris

1495

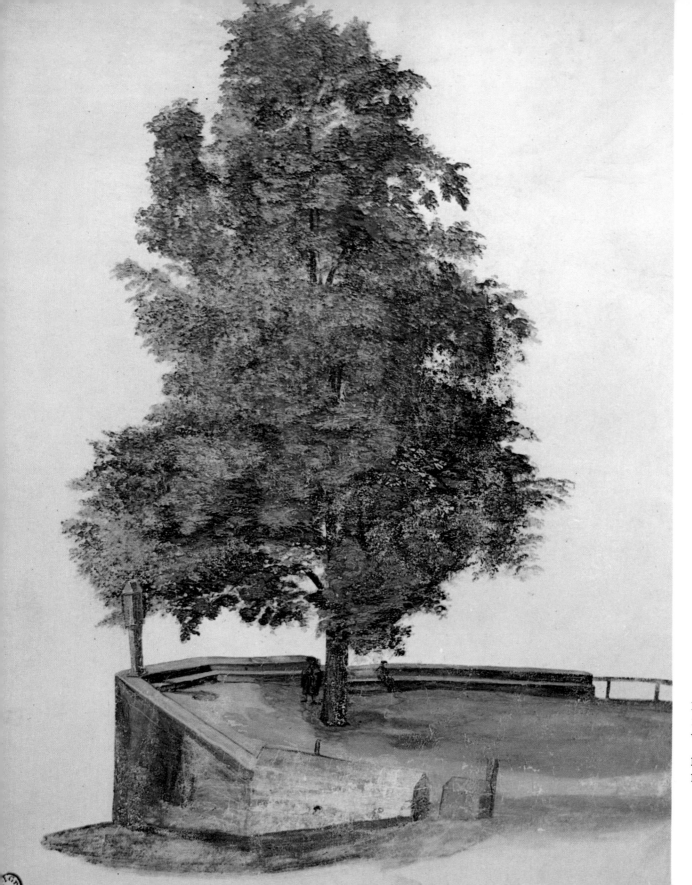

Pine tree on the ramparts
1494
Watercolour and gouache

Boymans Museum,
Rotterdam

Anyone who is looking for the romantic, the strange or the picturesque, will scarcely find it in Dürer, any more than he will find genre scenes in which the characters are represented or observed in precise situations.

For him, realism lies in the representation of objects and not in situations, as with Rembrandt. And if by chance we come across something which seems to be a genre scene, such as the magnificent *Man drilling a hole*, for example, we soon find that it is a study for a religious subject or borrowed from an Italian model.

His vision of things is so profoundly original that we, too, seem, to be seeing for the first time the objects he presents to us. The letters written during his stay in Venice and the journal of his travels in the Low Countries show how sensitive he was to the manifold aspects of daily life. This new way of looking at the world, so natural to us, was the start of great changes in the sixteenth century. Up to then, and ever since antiquity, knowledge had always been consigned to writing. Henceforth, by conscious observation of reality — as practised also by Leonardo da Vinci — artistic observation allies itself with scientific observation. By looking man learns to see and understand.

This way of observing the world cannot be dissociated from an insatiable thirst for knowledge. Leonardo da Vinci, more universal in spirit, carries his researches further than Dürer. That is because Dürer was handicapped by his initial training as a craftsman. But both aspire intensely to become what Rabelais calls *"un abysme de science"* — a deep well of learning — an ideal which Gargantua, in a letter of 1532, sets before his son Pantagruel.

After 1500, above all, Dürer concentrates on all sorts of objects and elements in his immediate surroundings. It is now that the celebrated studies of animals and plants appear, such as *The Hare* or *The Large Piece of Turf*, a whole fertile and flourishing world, which he evokes in gouache or watercolour. He dwells absorbed on a thousand enchanting details, but never losing sight of the whole. Matter, substance, structure, whether it be wood or feather, the skin of a face, a woman's hair or the sheen of metal, every detail is analysed and recorded with an infallible eye. There is something miraculous about the fact that he was able, in his engravings and his paintings, to re-create a coherent whole from the thousand details which are mainly revealed to us by his drawings.

Dürer carries his process of illustration by visual language so far that even for relatively abstract subjects such as fire, cloud, stones and water, we see him finding in his woodcuts a

form in which to render Biblical texts as literally as possible. We find this in particular in his series, the *Apocalypse*. By setting side by side objects represented literally, and therefore very concrete, he arrives at a composition which, as a whole, no longer bears virtually any relation to reality. The work then most frequently becomes, for a public which at that time could not read, a veritable language of images.

The relation which exists in Dürer between the visible world and language is one of the most captivating aspects of his art.

Dürer's contemporaries, too were conscious of the suggestive power of his realism. Did not Erasmus assert that he was great enough to represent "the irrepresentable", or almost language itself? Many centuries later Delacroix was to note in his journal, "I have noticed... that the true painter is the one who knows the whole of nature. Thus, with him, his human figures have no greater perfection than his animals of all kinds, his trees, etc. He does everything to the same degree, that is to say, with the sort of rendering involved in the advancement of the arts in his day. He is an instructive painter; everything of his is worth consulting."

Why did Delacroix call Dürer's work instructive? Not only because Dürer knew quite simply how to see and reproduce, but above all because he observed with intention. It was much more than merely observing, as Delacroix must have known. Dürer applied himself to the pure and honest observation of the world around him, and by that very fact, he sought a conception of the world in the deepest sense of the term. It is as though he was trying to find in things the originality with which Erasmus was able to inspire his edition of the New Testament and the texts of St Jerome (1516); the determination to penetrate to the sources — *ad fontes*. That is a very special feature of the humanists who, at the time of the Renaissance, placed art, aesthetics and science on the same plane.

Dürer's personal vision on the one hand, and on the other his intense interest in the whole essence of reality, faced him with a major problem which we find again today with many modern painters. In contemplating nature, the artist first had to find a harmonious balance between his love of detail and his interest in the quite newly discovered reality; but too much insistence on the details, and therefore on the accidental — the temptation of the craftsman — would be in danger of diverting attention from the essential.

Ceaselessly attentive to the presence of nature, he sought to break down the wall which separates it from art, while at the same time seeking stable rules which would allow him to

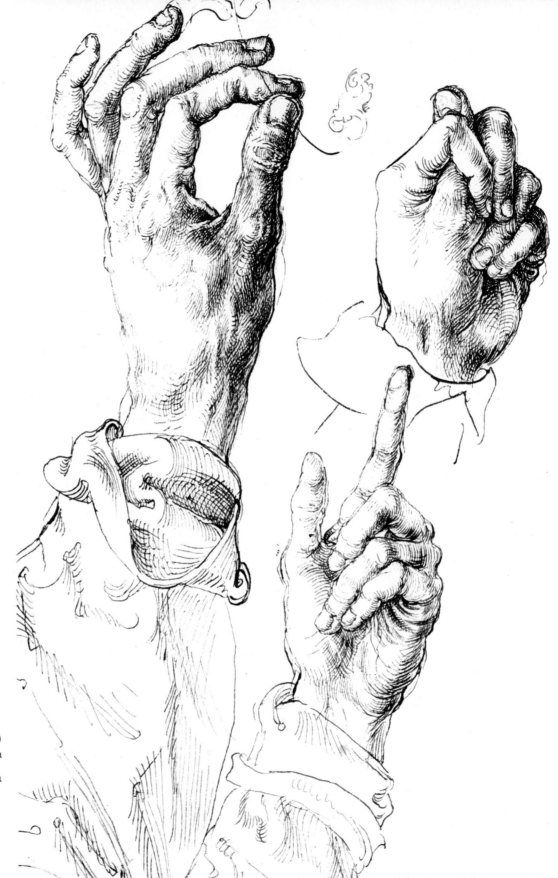

Study of hands (1484-1494)
Pen

Albertina Museum, Vienna

penetrate to the essence of things. But in order to attain this profound core, this very essence, he must strip nature of its transitory appearances.

It took him thirty years of striving to find a solution. Seeing and understanding, these two ideas were to merge for him, just as in his art theory merges with practice, "the deed with the word".

It is fascinating to follow the way in which Dürer was able to combine in his drawings his typically German love for craftsmanship, the detail, the individual and the exceptional with the need for clarity, measure and balanced proportions proper to antiquity and which he knew through Italian art and aesthetics. It is a sort of balancing between reason and inspiration, science and nature, formulas and experience.

No doubt his talks with his humanist friends helped him, with Pirckheimer first and then his encounters with the Italian painter Jacopo de' Barbari, whom he met in Venice about 1494-5 or in Germany around 1500.

It was only later that he became familiar with Leonardo's studies of proportions and with copies of his drawings. In any event, in his quest for universal values, Dürer constantly takes visible nature as his starting point; even when theory attracts him, nature remains his source of inspiration: "For in truth art is implicit in nature, and whoever can extract it possesses it", he said.

There in a few words is the essence of Dürer's art, and his conception of life is inseparable from it. He wanted to extract from life and nature the "Art" which they contained but at the same time he wanted both life and nature to remain recognizable in Art.

From this point of view, Dürer is a pioneer in an age when German art was in danger of getting bogged down in mannerism. But here he was to come up against a new problem. In his reaction against what he felt to be a set of false and outmoded conventions, he was trying, in a sense, to save reality... but reality is changing and impossible to fix in a framework of extreme naturalism. Nearly four centuries later, Marcel Duchamp was to say that the appearance of things is fine, it is true, but that their reproduction has something dead about it. The things which surround us already give us everything. Their representation no longer gives us anything.

For Dürer that was a grave problem with which he struggled during a great part of his life.

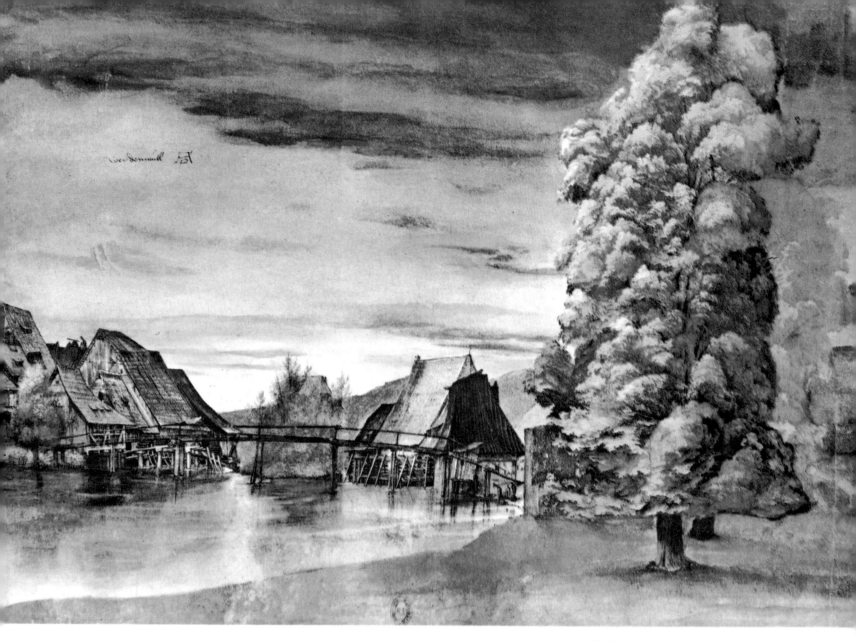

The watermill (1495-1497)
Watercolour and gouache

Bibliothèque Nationale, Paris

# The Magician of Black and White

**D**ürer regarded himself as a painter, and yet even his drawings give us a magnificent image of his grandeur and his universality. He has this in common with his contemporary Leonardo, and later with Rembrandt, that drawing is for him a form of expression in which he can give free rein to his imagination, his wealth of ideas and, above all, to his desire to penetrate the secrets hidden behind visible reality. Even more, like so many artists after him, Dürer is freer in his drawings, less hampered by principles of style, than in this paintings. That is precisely why the drawings are so attractive, since it is in them that we find the most spontaneous expression of his art.

With him, even writing becomes an element of importance, whatever the technique used, fine and flowing silverpoint, clear, firm brushwork, soft black chalk, rich and velvety charcoal, or even luminous and colourful watercolours. In looking at these drawings, we establish a sort of dialogue with them, we learn to speak with the artist, who thus reveals to us something of the secret of creation.

This dialogue — in the modern sense of the term — with a work of art had not always been possible, far from it. Before Dürer drawing was not recognized as an independent art form. With him it begins to free itself from the function it had fulfilled throughout the Middle Ages. In the centuries before Dürer drawings were regarded mainly as examples to be studied or as models to be used in the painter's or sculptor's studio. They were kept in volume form for consultation. But the more the eyes of artists opened to the individual appearance of men and things, around them, the more independent they became in their observations and the more personal became their drawings, which then began to be appreciated as characteristic of their author's creative gift.

1505

Man's head (1505)
Pen
British Museum, London

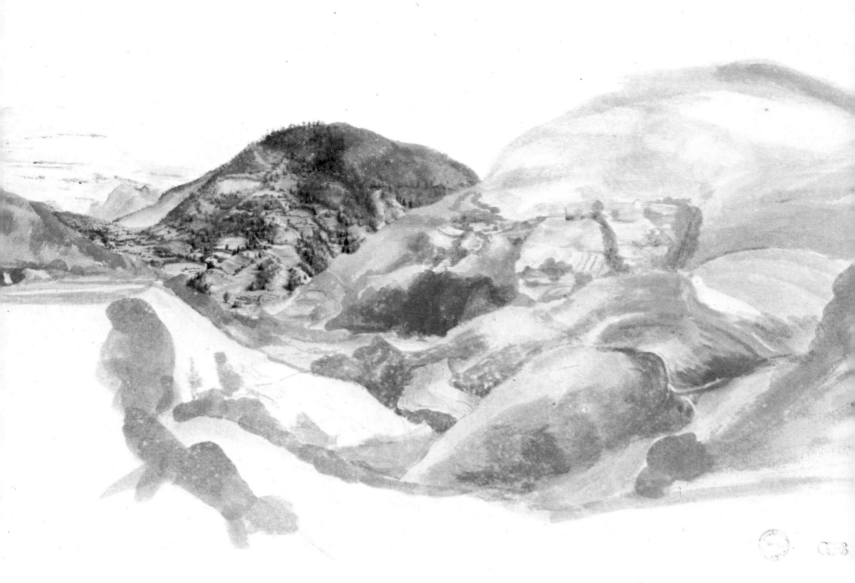

Mountains of Trentino
Watercolour and gouache

Ashmolean Museum, Oxford

The art of drawing in Dürer's time really begins to assume importance in the countries of the North where people were growing more and more attached to the personal handwriting of the artist and his quality. Dürer very soon felt the enormous evocative power of drawing. He wrote: "Very often the man who, in a single day, draws something with a pen on a sheet of paper or engraves it with a graving tool on wood, creates something richer and better than if he had spent a whole year on some major work. And this is a marvellous gift..." These words bear witness to the importance which Dürer attached to his graphic art; is it not a goldsmith's son who is speaking?

In the graphic domain, that is to say in the graphic comprehension of reality, Dürer is one of the greatest creative spirits who have ever lived. If it is exactly around this time that we find the first collectors of drawings, this is no accident. It is to these pioneer collectors — and among them, above all, to Willibald Imhoff, the grandson of Pirckheimer, Dürer's friend — that we owe the preservation of some thousand of the artist's drawings. These sheets are today the pride of the Albertina in Vienna, the British Museum, and the collections of Berlin, Hamburg, and the Louvre. The marvellous illustrations to the Emperor Maximilian's Prayerbook (in Munich) have also come down to us, illustrations which recall medieval miniatures, as well as the drawings of the *Fechtbuch* in Vienna and the sketchbook (studies of proportions) today at Dresden. But how many must have been lost! We have only a few studies for the great series of woodcuts. For many paintings, the preliminary sketches which must certainly have existed are completely missing. And there must surely have been many more sketchbooks similar to those of which we can form only a scanty idea thanks to the silverpoint drawings coming from two small parchment bound volumes, completely dismantled.

Thus, we can establish only a partial dialogue with Dürer's drawn work. There are serious gaps which we can fill only by our own imagination and the hypotheses of specialists.

Dürer thought in lines both in his graphic work and in his drawings. In all German art, moreover, line as a means of expression plays quite a different role from that assigned to it in Italian art. An eye accustomed to Italian art would no doubt have some difficulty in appreciating Dürer's drawings, since he looks for beauty and harmony less in the classical sense than in the reality and expression of lines. Dürer himself must have been conscious of this when he wrote on a sheet showing two male nudes in the style of Raphael : "Raphael of Urbino, whom the Pope admires so much, drew these nudes and gave them to Albrecht Dürer at Nuremberg to show him his manner."

Finally, Dürer cannot wean himself from the love of ornament so characteristic of the end of the Middle Ages. With him it is not a symmetrical or geometrical element but a free flowing calligraphy which he applies to the rendering of trees, branches, draperies, hair and a thousand

other things. To look at the delightful marginal drawings of Maximilian's Prayerbook, done as they were in his maturity (1505), is to yield quite simply to the pleasure of following the lines of his pen. We almost find there, translated in a freer and more naturalist fashion, the motifs of Irish script of the high Middle Ages. Even the somewhat confused composition and the play of many fingers in his celebrated *opus quinque dierum* show to what an extent, even in Italy, Dürer could still be Gothic.

The great collector and art lover, Paul J. Sachs, rightly points out that Dürer, in spite of his visit to Venice, remains faithful in his portrait of his mother to the most typical German characteristics.

This highly expressive drawing foreshadows the twentieth century "expressionism" of North Europe, of Munch or Nolde, Kirchner, Beckmann and others.

Dürer used all the techniques of drawing known in his time, except red chalk. He disregards this medium which enabled Leonardo da Vinci, Michaelangelo and Raphael to fill immortal sheets; it is not found in Germany until after Dürer's death. This process was no doubt too pictorial and not graphic enough for him. It is therefore not surprising that the pen — at that time the goose quill — was his favourite medium.

In his youth he used the pen cautiously and still with great reserve, in short hatching, but as early as about 1494, a very spontaneous drawing — on which he has added "mein Agnes", his wife — shows a freedom and precision which makes us think of the pen and ink drawings of Rembrandt or van der Gheyn a century later. Finally, around 1510 appeared the brilliant pen and ink studies, so full of ease, in which Dürer dared to render shadow by long parallel hatching, with a virtuosity and bravura which evoke the great Italian masters.

We always have to ask what was his purpose in making a drawing since that directly determines his choice of technique. An experienced engraver and draughtsman, Dürer has indeed an infallible sense in harmonizing the form, function and content of a sheet. His big portraits are done in charcoal or pastel, his elaborate nature studies in gouache, detailed studies for his paintings in pen and ink, sometimes heightened with the brush. The drafts of his great compositions are done in pen and ink in a sort of shorthand, but, in contrast, he works with the greatest care, with a very fine brush on a coloured ground, the detailed studies which he afterwards wants to set in a painting; everyone knows the magnificent set of studies for the Heller altarpiece (1508).

The sketches for woodcuts or copperplate engravings are of the most varied types. Thus, the sketches made during his visit to the Low Countries (1520) are in silverpoint on the small pages of a sketchbook he probably carried around with him.

26

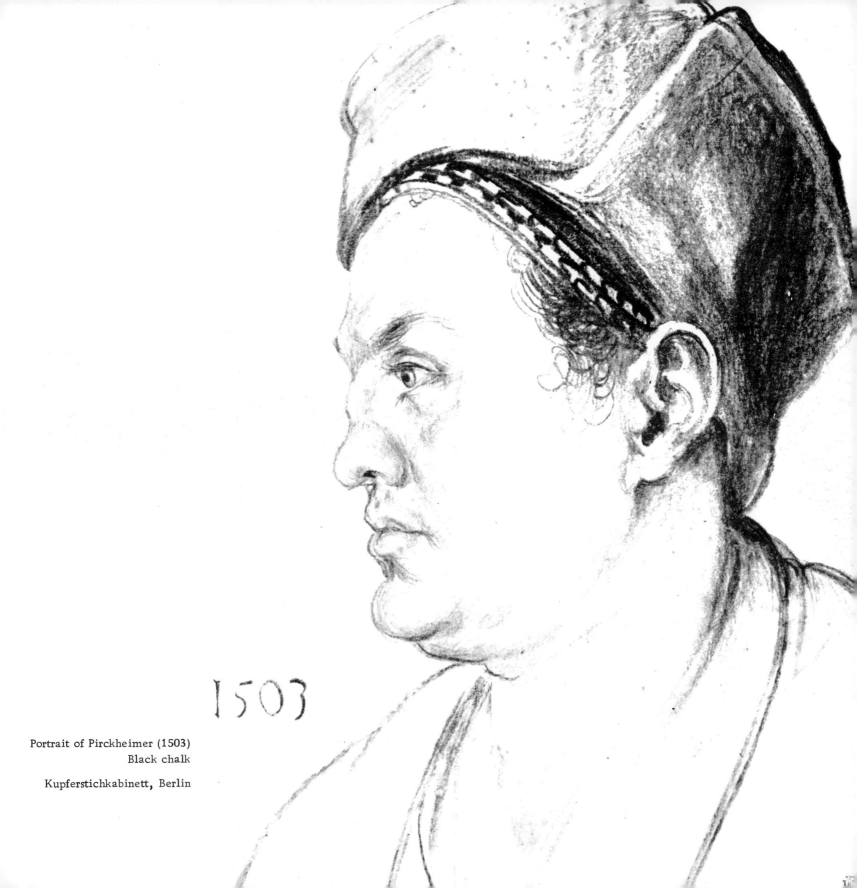

1503

Portrait of Pirckheimer (1503)
Black chalk

Kupferstichkabinett, Berlin

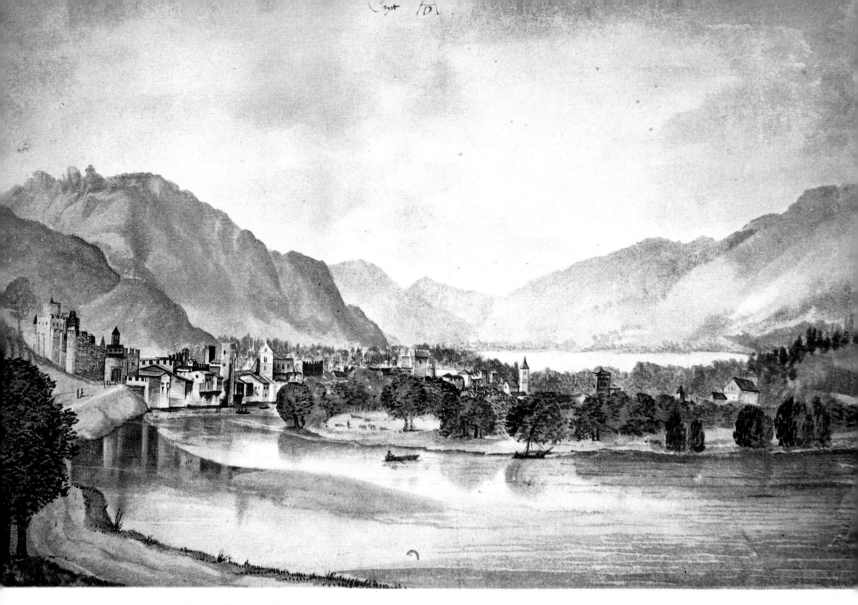

View of Trent (1495)
Watercolour and gouache

Formerly Kunsthalle, Bremen

On his second visit to Italy, Dürer became acquainted with a certain number of new technical processes. Thus, blue paper, *carta azurra*, was just coming into use there. Similarly, charcoal was experiencing a new vogue in Venice, in Titian's studios among others, now that the technique had been learned of fixing it on dampened paper, thus making the work less fragile. In his later protraits, in particular, Dürer often uses pencil alongside charcoal. At Venice, too, he must have learned the *sfumato* technique, which appears in his first portraits and accentuates their plastic side; he uses it in the portrait of Pirckheimer.

But it is in his brush drawing that Dürer is unequalled. This technique was already known in Germany before him, and used, for example, for stained glass and woodcuts; but Dürer, especially after his second Venice visit, raised it to unprecedented heights. The studies for the Heller altarpiece and the portrait of an *Old Man of Ninety-three*, done during his stay in Antwerp, show what he could do brush in hand. Involuntarily, one thinks of the story told by Joachim Camerarius; Bellini admired the incredible fineness of Dürer's brush drawings to such an extent that, in order to convince his colleague, the German master had to demonstrate that he was capable of drawing the finest lines with an ordinary brush. More rarely, he uses it broadly, almost in the modern style, in landscape studies. Sometimes he lets himself be tempted to use the brush in studies of drapery, and heightens it with wash to bring out a figure or an object more sharply. This is visibly the case in the penetrating and unforgettable portrait which is believed to represent the German architect of the Fondaco de Tedeschi in Venice. It is one of the most brilliant preliminary studies for *The Feast of the Rose Garlands* (National Gallery, Prague) — today, alas, in such a lamentable condition — painted for the chapel of the German merchants during his second visit to Venice. We can clearly see there how the hatching is merged into the wash.

His aversion from the picturesque, the strange and the confused, and, above all, his taste for the linear, explain the importance of graphic works in Dürer's art. That was why the sixteenth century could call him "the Apelles of black and white".

As Dürer grew older, he was to move further and further away from the still so Gothic pen and ink drawings of his early days, with their play of complex, knotted, broken lines. A fine and very charming example of still completely medieval drawing is preserved at Hamburg, the *Pair of Lovers* (about 1490-4), believed to be a portrait of the artist with his young wife. The realistic character of this drawing clearly shows the influence of the delightful narrative graphic style of the Master of the Hausbuch.

The quite remarkable individualization of the faces already shows that Dürer is about to follow a different line.

# A Craftsman turns Artist

It is significant that Dürer's first known work should be a self-portrait in silverpoint on a prepared ground, a traditional medium but difficult to handle and allowing practically no corrections.

When he drew this portrait in 1484, the young Dürer cannot have been more than thirteen. He later noted in the margin: "I drew this with a mirror, from life, in 1484 when I was still a child."

This drawing is the oldest self-portrait known in German art. To draw a portrait of this kind at Nuremberg at that time was something completely new. Naturally it is a youthful work with obvious weaknesses, for example in the drawing of the hand, the indication of the eyes and the volume of the clothing. But one already feels, from the astonishing sense of form, from the intensity of the look and from the subtle rendering of the mouth, that one is in the presence of an artist of genius. Dürer here gives form, as he was to do later in his landscapes, to something which no one had seen before him. This is a special gift of great artists.

The self-portraits done a little later, among others the Erlangen drawing (about 1491), show the rapid changes which had taken place in the artist. The intensity of expression is more striking and the pen lines more convincing, though obviously owing something to Schongauer's style, while the hand adds an even more impressive accent to the whole.

Other portraits in which the hand is near the face show how much this theme interested Dürer. Other drawings emphasize the marvellous certainty with which he could draw hands.

Fairly soon, Dürer left his father's workshop to go as pupil, in 1486, to the painter and engraver Michael Wohlgemut, with whom he stayed until 1490. After that he travelled. No doubt his father, who had been an apprentice in the Low Countries, had spoken to him of the great Flemish masters, of van Eyck and Roger van der Weyden.

MEMENTO MEI
1505

Death on horseback (1505)
Black chalk

British Musuem, London

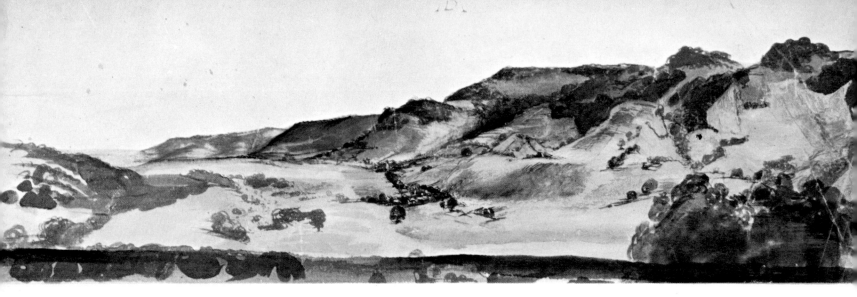

Environs of Kalchreuth (1495-1497)
Watercolour and gouache

Kupferstichkabinett, Berlin

No trace of these travels survives, and we dot not know where he went, but in 1492 we find him at Colmar. Schongauer, whom he had wanted to see, had just died. In 1493 he was in Basle, where he did some woodcuts, and then he set off for Strasbourg, where he painted a self-portrait, which displays in even more marked form the consciousness he already has of his own genius, an assurance which appears again in the drawing in the Lehman collection; he was now 22.

In May 1494 he came back to Nuremberg, where he married in July of the same year. The *Pair of Lovers*, referred to above, dates from these years. We see Dürer gradually divorcing himself from the tradition of craftsmanship and becoming an independent artist, blossoming with all the wealth of an enormous intellectual curiosity. It was a process which had already made its appearance in Italy. Did not Uccello, Antonio Pollaiuolo, Verrocchio, Ghirlandaio and Botticelli all also begin their careers as goldsmiths?

Architects, sculptors, painters and engravers were all trying in the course of the sixteenth century to rise in the social scale. Dürer can be regarded in this respect as the first artist of independent personality in Northern Europe. Through his theoretical knowledge in the field of mathematics, perspective, geometry and the like, he could rival his intellectual friends, the humanists.

As a number of princes — in Italy first, but soon in Germany too — made it their business to patronize artists, the domination of the corporations weakened. Intelligent, full of curiosity and widely read, Dürer was able to associate with the greatest scholars of his time and to discuss with them religion, philosophy and astrology as well as the sciences.

The humanists, for their part, looked upon artists as an opportunity for gaining a wider audience for their ideas and their theories, to such an extent that the plastic arts and literature were ultimately regarded as a unity, a concept which would have been unthinkable in the medieval workshop completely given over to manual labour. Dürer had no doubt observed in Italy that the status of artists there was quite different from what he knew in Germany. Did not Leonardo regard painting as "poetry without words", requiring the same inspiration? When the Venetian de' Barbari arrived in Germany, he handed to Frederick the Wise, his patron, a memorandum on the social position of the artist: "Art must be snatched from the hands of beggars and entrusted to men of the *élite*, capable of elevating it."

It is therefore not surprising that Dürer could write to his friend Pirckheimer from Venice, where artists were respected and admired, "Here I am a lord, there I am a parasite." That is indeed the bearing that we can see in his self-portraits. The most famous, that of 1498 in the Prado, shows us a refined and elegant patrician, a man whose social position differs visibly from that of his father or his masters. Dürer depicts himself as a humanist, without brush or palette.

He must have been fully aware of the new position he occupied as an artist, since he wrote: "There were in Germany at that time many young men of great talent, who had learned to paint solely from daily practice, without any theoretical knowledge, and so they developed without consciousness, like wild plants."

He compared them with his Italian colleagues who "two centuries ago had rediscovered the art of the Greeks and the Romans, lost for a thousand years".

The very fact that Dürer, according to Vasari, sent Raphael one of his self-portraits shows how conscious he was of his own value.

This feeling and this profound conviction are even more firmly asserted in a famous painting, which can be ranked as one of the most remarkable portraits in history, the portrait painted in 1500, now in Munich, in which Dürer depicts himself as Christ.

In this *Imitatio Christi*, he felt himself, as artist, to be elect; he who gives divine beauty to the world. It is a thought which we find again, in a slightly different form, in the "divine Michaelangelo". Later still, in 1522, this idea appears again with Dürer, when he portrays himself bearing the instruments of the·Passion (formerly in the Kunsthalle, Bremen).

# The Discovery of the Individual

For Dürer, the main function of art is "to preserve the appearance of man after his death".

Right through his life we find this constant interest in the physical features specific to each individual. Thus he executed a series of magnificent portraits, many of which have come down to us.

Some periods of his life seem particularly fertile in this field. Around 1499 at Nuremberg, for example, and during his stay in the Low Countries (1520-1) Dürer notes in his journal that he executed seventy portraits, sketched during his visit to the Low Countries.

He sold them, or, even more frequently, presented them to his hosts and his friends.

The style of these portraits cannot be associated with any local tradition; this can already be seen in the self-portrait of 1484, when he was still a child. But he had to take account of the prejudice, rife in his time, which regarded the execution of a portrait as a less creditable occupation for an artist than a religious work. That is why, in the words cited above, he expressly names portraiture as the second major function of the artist. When we remember that in Hartmann Schedel's *Chronicles of the World* the same engraving of a crowned head was still used to represent any number of princes indiscriminately, we can realize the extent to which Dürer was attracted by the special unique character of each individual. He was to react in the same way when he discovered the unique aspect of a landscape.

Portrait of his wife Agnes
Pen

Albertina Museum, Vienna

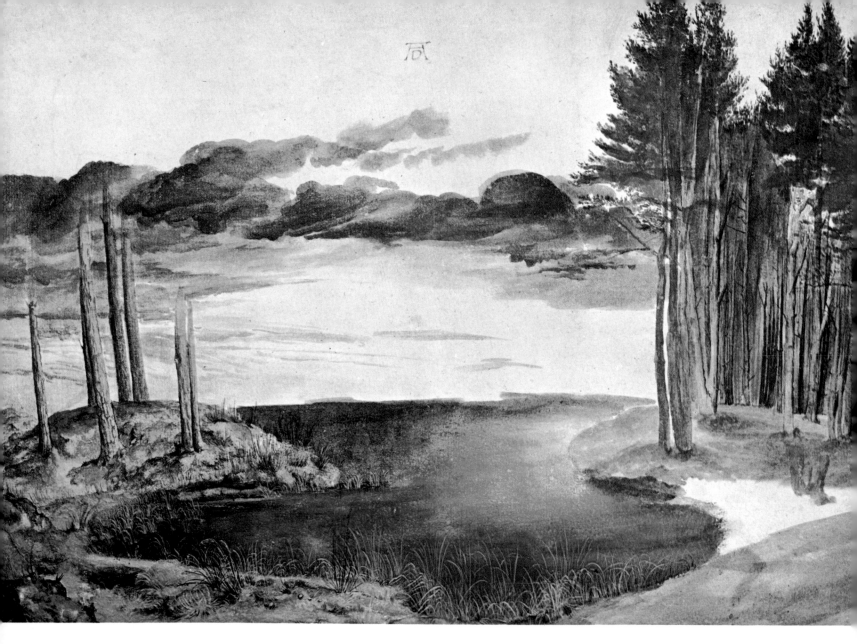

The lake in the forest (1495–1497)
Watercolour and gouache

British Museum, London

Dürer's portraits are more than a new form in plastic art, they embody a new spiritual content, they express a new ideal of culture.

Each age has its own particular concept of the ideal man, and the world in which Dürer lived thus had a certain image of man before its eyes. The essential element of this human ideal was *Humanitas*, which included the art of living as well as the highest qualities of culture and civilization; the main ambition was man's study of man.

From childhood, Willibald Pirckheimer was one of Dürer's closest friends. As boys they must have played together at Nuremberg, where Doctor Johannes Pirckheimer, Willibald's father, let part of his house to Dürer's father. Pirckheimer later studied at Padua and Pavia.

Dürer must have had many contacts with the humanist circles in which Pirckheimer moved. Pirckheimer introduced him to antiquity, philosophy and mathematics, and it was probably with him that Dürer began to discuss the burning problems of faith. Without Pirckheimer, Dürer's humanist culture would be unthinkable.

These contacts were of the greatest importance for his art, since a great many of his famous engravings, mysterious and hardly studied, seem to have been inspired by Pirckheimer and his friends.

In contrast with his woodcuts, whose Christian subjects must have had a far wider public among the simple folk, Dürer seems to have reserved the finer and more ambitious technique of copperplate engraving for humanist subjects.

Thanks to Pirckheimer, Dürer made the acquaintance of a number of other scholars, especially the famous Konrad Peutinger. Peutinger lived at Augsburg, where Dürer was his guest, and it was no doubt on this occasion that Dürer executed his portrait. Peutinger, in turn, introduced him to the wealthy bankers, the Fuggers, whose portraits Dürer also drew. During Dürer's stay in Antwerp in 1520 they welcomed him with hospitality in their trading house.

We also have from Dürer's hand a portrait and an engraving of the learned Ulrich Varnbüler, who translated Erasmus into German, and a portrait of Eobanus Hesse, the leading spirit of a group of young poets, admirers of Erasmus and Luther.

Dürer kept up a sustained correspondence, not only with these scholars and many others, but also with Erasmus. We know that during his visit to the Low Countries he drew two portraits of "the Marvel of Rotterdam". One of them is probably the drawing now in the Louvre. On

this occasion, according to Dürer's journal, the artist presented Erasmus with a set of his copperplates on the Passion. While Dürer was drawing Erasmus's portrait at Brussels, King Henry VIII's Astronomer Royal, Nikolaus Kratzer, was present at the sitting. It was this same Kratzer who in turn introduced Hans Holbein to the King of England. We can see how small was the world of artists and scholars; everyone knew each other. On 8 January 1525, Erasmus wrote a letter of thanks to his friend Pirckheimer, who had sent him his portrait by Dürer. Althrough Erasmus writes "pictum ab Apelle", whereas no painting of Pirckheimer is known, it was in all probability the 1524 engraving. Erasmus goes on to say "I should greatly like to have my portrait by Dürer's hand; who would not wish it from such a great artist!" He was obviously thinking of a painted portrait, since Erasmus had already been drawn twice by Dürer in 1520. In any event, we are familiar with the famous engraving of 1526.

The Diet of Augsburg, in 1518, was a unique chance for Dürer, since it gave him the opportunity of seeing the leading men of Germany at close quarters and of drawing them. He painted portraits of the Emperor Maximilian, of Jacob Fugger, and no doubt also of Cardinal Albrecht of Brandenburg, of whom he also made two engravings. This humanist prince was a great lover of art and literature. He had attached to his court at Mainz such famous scholars as Stromer, von Hutten and Capito.

Albrecht seems at first to have sympathized with the ideas of Luther and the Reformation, but later, for money reasons, he took part in the traffic in indulgences and became one of the most violent partisans of Catholicism.

The profile portrait in silverpoint, now in the Louvre, is a study for the great engraving of 1523. It impressively depicts the decisive and dominating character of this Prince of the Church; the lips, eyes, nose and chin are living almost to the point of caricature.

Equally brilliant is the silverpoint portrait of Frederick the Wise, Elector of Saxony, who sympathized with the theories of Erasmus and protected Luther. We know that this prince stayed in Nuremberg from November 1522 to February 1523, to attend the Diet. The drawing, which was later engraved, must have been done at this time.

The portrait of Pirckheimer drawn by Dürer is one of the summits of German portrait art. It was done in 1503, the year when Dürer began to use charcoal. What a powerful look, under the hair marked with a bold line descending to the nape of the neck! The ear is drawn in masterly fashion, and so are the fleshy chin and the nose; the profile is astonishing. This representation of his

Hans Burgmair (1518)
Black chalk

Ashmolean Museum, Oxford

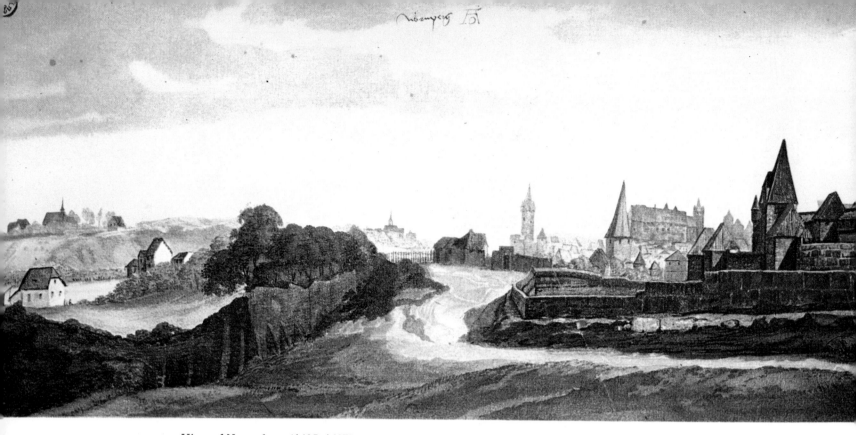

View of Nuremberg (1495–1497)
Watercolour and gouache

Formerly Kunsthalle, Bremen

friend's profile certainly suggests that he intended to strike a medal of him.  Above all, it must be taken as a sign of his great admiration for Italian art, in which profile portraits are so often found.

The many letters of Pirckheimer which we still possess show him in exactly the same light as this powerful portrait, a frank and open man, with an honest character, who, moreover, was far from being a scholarly recluse.  In everyday life he was anything but austere, especially after the death of his wife in 1503; his conversation was interesting and witty; as well as being a scholar, he was an enthusiastic athlete.

We recognize here something of the atmosphere of Balthazar Castiglione's book *Il Cortegiano*, which, moreover, was published only in the year of Dürer's death.

After the artist's death in 1528, Pirckheimer wrote that he had just lost his best friend and shortly after accused Agnes Dürer of having hastened her husband's death by her bad temper and cupidity.  Indeed, Dürer had not had many pleasant things to write about his wife.  In his portraits of her, she hardly seems a cheerful person.  Perhaps Agnes who was, incidentally, childless felt that Pirckheimer was leading Dürer into a world which was closed to her and where she could not follow him.  And yet she went with her husband on his travels in the Low Countries.

This visit represents Dürer's most fertile period as a portraitist.  Famous and fêted, he met countless friends and acquaintances, and at Antwerp, among others, the young genius of Leyden, the painter Lucas, who was then about thirty-two.

How we should like to have overheard the talks between these two men, the most famous living artists of North Europe!

Did they speak of their Italian contemporaries or of portraiture, an art in which Lucas van Leyden was so close to Dürer?

The Museum of Lille preserves a record of this meeting, the portrait by Dürer of his young colleague, a silverpoint drawing.  It was a happy find of Jean-Baptiste Wicar, an almost forgotten painter of the early nineteenth century and a great collector, who doubtless never knew that this drawing represented Lucas van Leyden.

Dürer speaks of this meeting in his travel journal; "I was the guest of Master Lucas, who works with the graving-tool; he is a little man, originally from Leyden in Holland, who is now in Antwerp... I have done Master Lucas's portrait in silverpoint."

In the portrait Dürer makes a virtuoso's use of a chequerwork of lines inside a very finely and clearly drawn outline in silverpoint.  It is an engraver's technique.

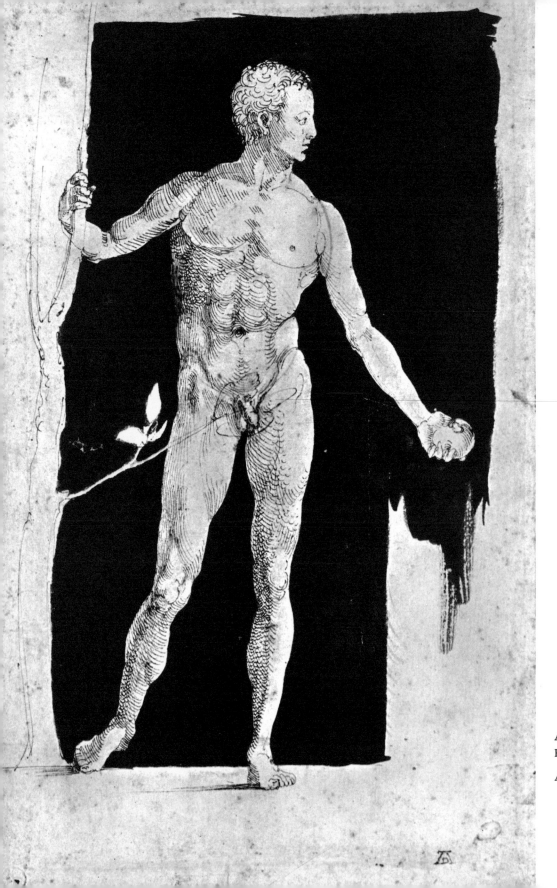

Adam (1505–1507)
Pen and wash

Albertina Museum, Vienna

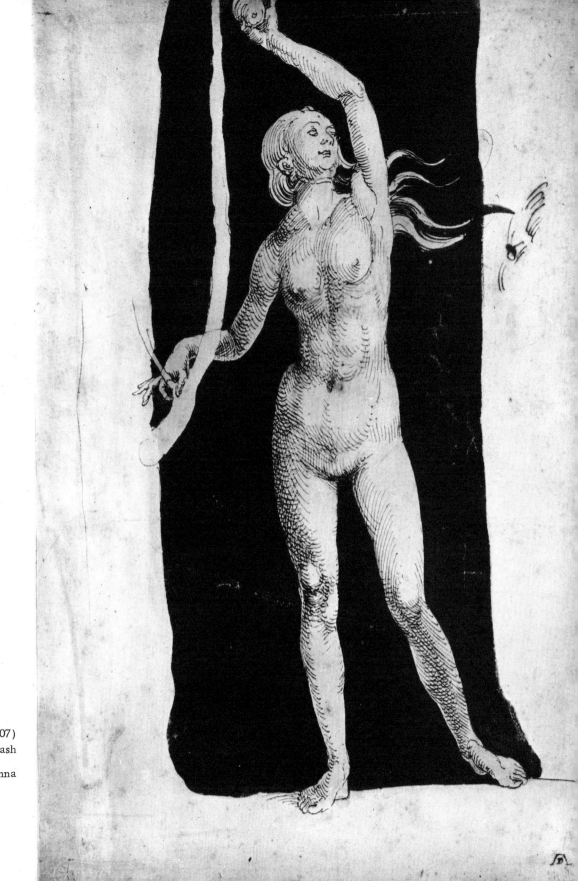

Eve (1505-1507)
Pen and wash

Albertina Museum, Vienna

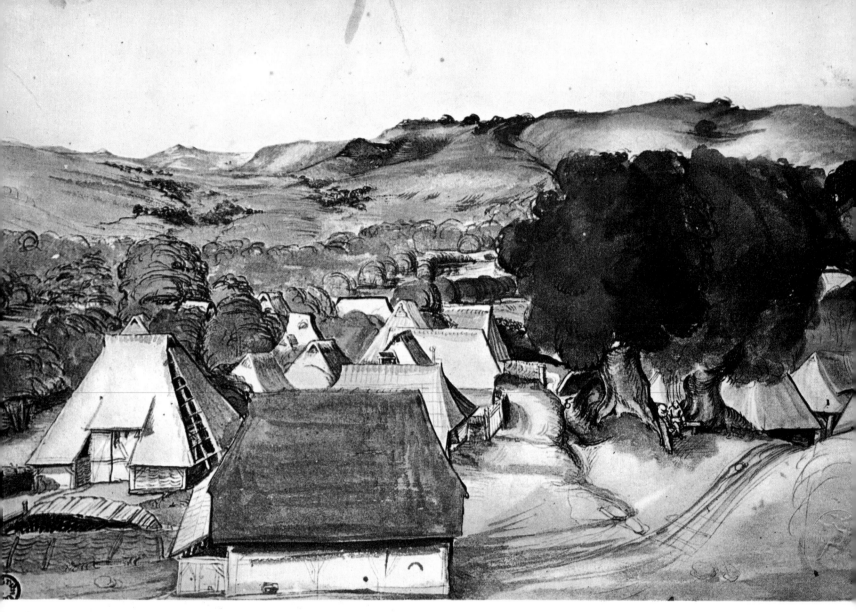

View of Kalchreuth (1495-97)
Watercolour and gouache

Formerly Kunsthalle, Bremen

The dreaming look, gazing into the distance, gives this portrait something particularly silent and fragile.

The Italian painter and writer Vasari places Lucas van Leyden in some respects above Dürer, as does van Mander in his book. No only does he praise his gifts of observation, but, in his view, Lucas observes the "rules of the art" better than Dürer.

If Vasari could have seen Dürer's impressive, almost life-size, portrait of his mother, he would no doubt not have persisted in this opinion. This drawing is not only one of the most remarkable portraits in German art, but one of the most expressive ever made.

Dürer drew this portrait barely two months before his mother's death, and noted on the sheet in charcoal, "19 March 1514. This is Albrecht Dürer's mother."

This woman, mother of eighteen children, of whom Albrecht was the third and only three of whom were to live to grow up, had a hard life. Dürer wrote of her in the family chronicle: "After my father's death (1502) her health was always poor... I can never sufficiently praise her acts of kindness and her pity for others, nor say how universally she was respected. My pious mother bore and brought up eighteen children, often suffered from the plague and other serious illnesses, and experienced great poverty, mockery, contempt and opprobrium, yet never became vindictive."

Dürer's mother, Barbara Holper, was married at the age of sixteen in 1467; she was the daughter of the goldsmith Hieronymus Holper of Nuremberg. Dürer's portrait of her is treated very boldly and particularly expressively, which sometimes prejudices clarity. Dürer has concentrated solely on psychological expression. Without embellishing the reality, he has rendered in charcoal, as an acute analyst, the furrowed neck and cheeks, the prominent cheekbones, the slightly cross-eyed look, the toothless mouth and the scanty hair, and he has softened off the skin with his fingers.

This sheet gives us a touching image of the fragility of human existence, an image which survives the shortness of life and stirs us as one of Dürer's greatest creations.

Wölfflin has written magnificently that in this portrait ugliness attains the height of grandeur.

There can be no better example of the contrast between the Italian ideal of beauty, as we find it in Raphael's drawings, and the Germanic sense of form. In Italy, as Alberti says, beauty is the perfection of an object rendered as truly as possible — but the subject must be harmonious — while in Germany the artist is convinced that the quality of a work of art is independent of the beauty of the model.

# The Birth of Landscape

Shortly after Dürer's marriage with the young and wealthy Agnes Frey of Nuremberg a violent epidemic of the plague broke out in the town.

Very quickly, a third of the population (25,000 people) died. Everyone who could do so fled. Dürer, too, set off. There is nothing surprising about his choice of Venice as a place of refuge. Together with Rome and Florence, it was one of the most flourishing Italian cities of the time and its links with Nuremberg and Augsburg had been very close ever since the twelfth century, thanks to a very active trade. Many wealthy Nuremberg families, such as the Imhoffs, the Fuggers, the Paumgärtners, the Pfinzings and the Tuchers — names which have become famous in art history — sent their sons to Venice to finish their education.

Dürer set off in September 1494, to arrive in Venice after a three-week journey by way of Augsburg, Innsbruck, the Tyrol, Klausen, the Brenner Pass, Trent and Arco.

During this journey, and no doubt even more during his return journey in the spring of 1494, Dürer executed landscapes in watercolour. Of these we still possess some fifteen marvellous examples, which can be numbered among his most brilliant and astonishing creations. It is hard to believe that these precious watercolours and gouaches are already five hundred years old. They might have been done yesterday.

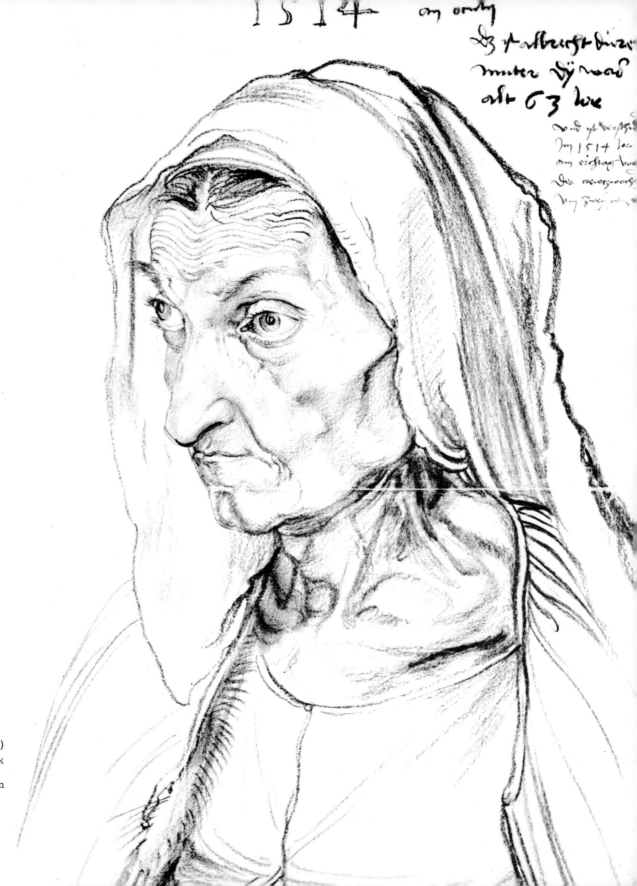

1514

Portrait of his mother (1514)
Black chalk

Kupferstichkabinett, Berlin

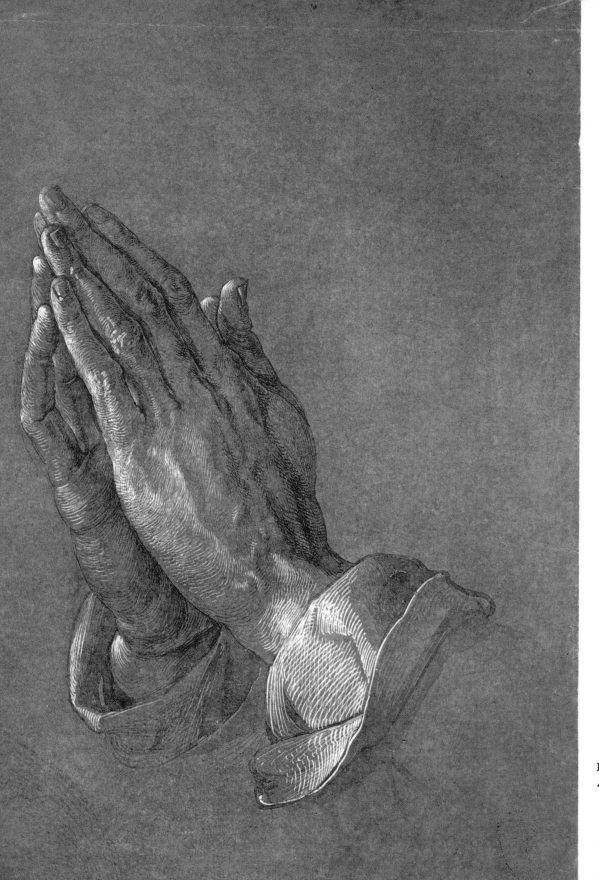

Hands of an Apostle (1508)
Albertina Museum, Vienna

Dürer's interest in landscape can already be seen in his earliest drawings (for example, the background of the pen and ink drawing of the Holy Family of 1492-3, in Berlin). Dürer had certainly seen the Flemish landscapes, either directly or through the works of his father or Schongauer. And one cannot help thinking here of Jan van Eyck's feeling for nature or the marvellous landscape of Hugo van der Goes in the Portinari altarpiece.

Another *avant-garde* painter, Conrad Witz, was probably before Dürer in using studies from nature of the Lake of Geneva for his picture the *Miraculous Draught of Fishes* (1444), but an almost impressionistic representation of nature in watercolour and gouache, such as the famous Oxford drawing called *Wehlsch Pirg* is a unique thing, not only because of the technique employed by the artist, but also because Dürer seems to have done such watercolours solely for his own pleasure. They are souvenirs of a personal emotion in the face of nature, a perfectly modern point of view.

We find this phenomenon again only in the landscapes of Vandyck and Cézanne.

Dürer's watercolour landscapes affect us immediately by their freshness, they give the impression of being much less contrived than the landscapes we find with Cima da Conegliano, Giovanni Bellini or Carpaccio. They are executed with a disturbing precision which overlooks no detail; the *View of Arco* in the Louvre, a whole harmony in blue and green, is one of the earliest and most brilliant examples.

Can you not feel the breeze blowing, the plants perfuming the air?

Dürer's earliest watercolour or gouache landscapes were done in the course of his excursions in the neighbourhood of Nuremberg. These sketches show the interest and intensity with which he observed the external world.

It is true that topographical views of Nuremberg are also to be found in the work of his master Wohlgemut, but Dürer's work breathes a completely new spirit.

These first sheets are sometimes done on parchment. They are clumps of trees — like the magnificent tree on the bastion of Nuremberg, now in Rotterdam — watermills, valleys and villages.

The Rotterdam drawing probably dates from the summer of 1494, like the *Drahtziehmühle* and the *Johannis Friedhof*, the cemetery where Dürer himself was to be buried in 1528.

Winkler describes the 1494 drawings as "the first independent landscapes in painting which represent a precise place" and likewise speaks of a view of Innsbruck drawn by Dürer

in 1494 on the road to Italy as "the first identifiable landscape in modern art".

The watercolour in the Bibliothèque Nationale in Paris is particularly astonishing; it is heightened in pen and reverts to a subject which Dürer had already treated around 1498-1503 or even earlier, the watermills at Pegnitz, near the Halle gate of Nuremberg.

The drawing is very different from the *View of Arco*, now in the Louvre. By its daring colour, the monumental tree which rises up on the right stands out sharply against the orange red evening sky. Even more astonishing is the *Sunrise*, now in London, an unfinished drawing in which Dürer recognizes an expressive value in colour which is exceptional for him, a value which was not to appear again until the Romantic period.

We find in these landscapes the dramatic and pathetic character which, about 1498, he was to imprint upon the visions of the Apocalypse.

It is particularly regrettable that Dürer did not afterwards continue to paint similar landscapes. It is a culminating point of his work, but it has no sequel. Similar creations are only to be found in Altdorfer and the artists of the Danube school, but lacking the ingenuity with which Dürer approached nature.

The earliest landscapes, long before the Italian visit, have a very analytical character. Later come the broad spaces, violently lighted, which are striking in their highly accentuated horizontal character. The models of North Italy certainly play a part here.

What interests Dürer in fact is not so much the picturesque as the difficulty of placing objects in space. In such landscapes the artist is conscious of the importance of light, air and space. Twenty years later Dürer attains a summit in the famous engraving of *St Jerome*; no artist has ever equalled the quality of the limpid silver light of this engraving.

Dürer's interest in Landscape is closely akin to the curiosity which impelled his contemporaries towards distant seas and opened their eyes to new aspects of nature and its diversity. Anyone who compares Dürer's watercolours with the stereotyped city views of Wohlgemut will find it hard to believe that such a change could come about in the course of a few years.

The Italians, too, must have recognized the value of Dürer's evocative landscapes; look at the paintings of Lorenzo Lotto and the pen and ink landscapes of Fra Bartolommeo, whose graphic style sometimes reminds us amazingly of Dürer. In the eyes of the Italians, the German artists were very advanced; does not Vasari tell us that Titian invited German artists to visit him so that he could study their progress in the domain of landscape?

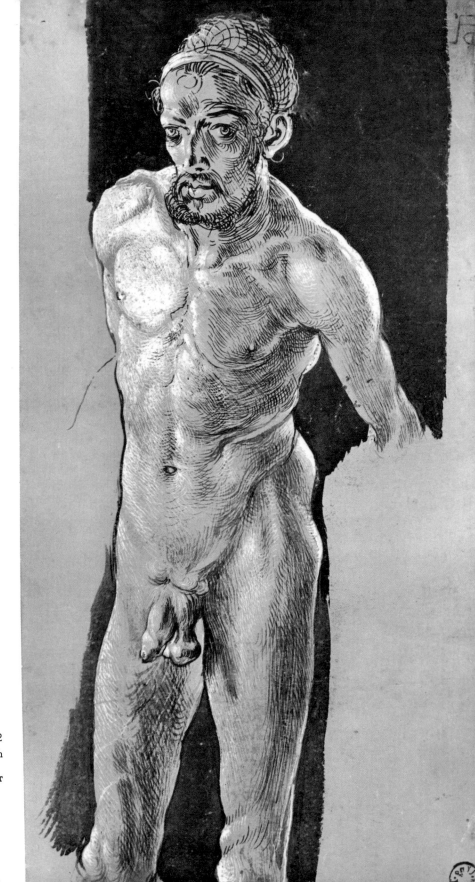

Nude study (self portrait), 1502
Pen and wash

Schlossmuseum, Weimar

We constantly find Dürer re-using his early landscape sketches as the background for his graphic work, not only for the Apocalypse, but also in his copperplate engraving.

Thus, in the famous engraving *Nemesis*, or *Large Fortune*, he repeats a view of the village of Klausen in the Tyrol.

Why do we not have more landscape studies by Dürer after the year 1500? Have they been lost? Or is Dürer more and more fascinated by theoretical studies which hardly lend themselves to the analysis of a landscape?

How we should like to have just that part of his notes on the theory of proportions which deals with landscape, notes which are now lost, but which we know to have existed!

What was to interest Dürer later was the rendering of figures in volume in space. This problem has troubled European artists from Giotto to Picasso. Dürer had much to learn from the Italians in this sphere, which called for greater precision drawing and therefore a withdrawal of the pure pictorial element, so powerfully expressed in his watercolours, in favour of plasticity.

The evolution experienced by Dürer in the direction of simplification and at the same time of the sublimation and synthesis of the seen reality, appears clearly in a drawing which evidences the point of perfection which Dürer had reached. This drawing — the view of the port of Antwerp in 1520, today in Vienna — has no peer in European art.

This view of the city, constructed along a simple diagonal, possesses a purity and limpidity which reflect the maturity of a great master.

This masterly and so clearly constructed landscape of the banks of the Scheldt is one of his most impressive drawings.

The absolutely new conception of space and nature, and the play of the lines of masts and rigging, recall van Gogh. The two great radiant white fields, the sky and the quay, are both surprising and daring.

Here it is the white, that is to say, nothingness, which becomes beauty. It is a silence which becomes "audible" because of the brief notes which frame it, a negative which, by its significance, becomes positive. Dürer could not have added anything to it without thereby taking something away.

We find the same sense of the essential in other late drawings of Dürer.

White is used there in the same way as a vocal pause in a poem. How much music and poetry, how many plays, there are which owe their beauty and their power of expression precisely to these silences!

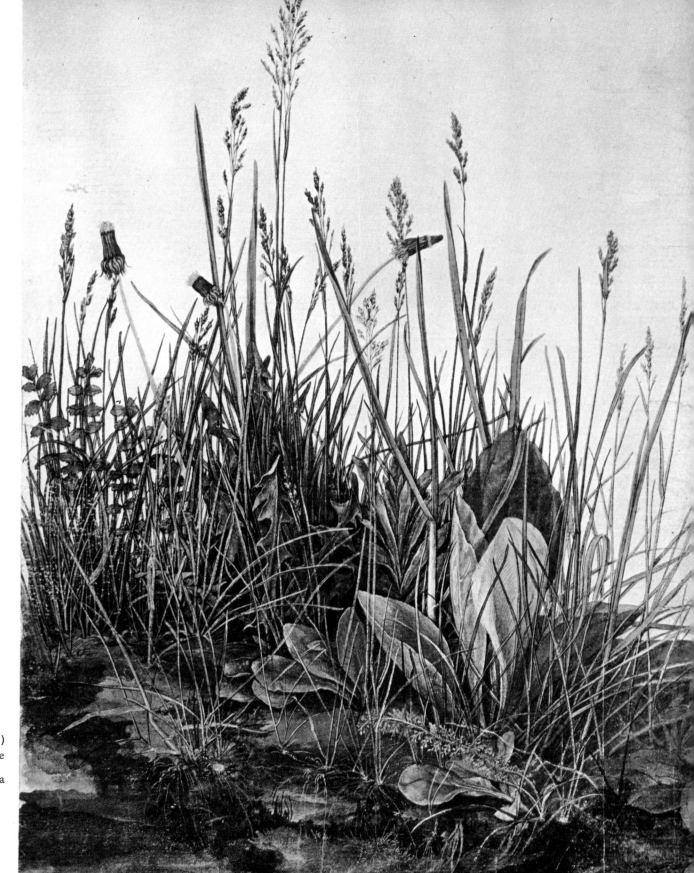

The great piece of turf (1503)
Watercolour and gouache

Albertina Museum, Vienna

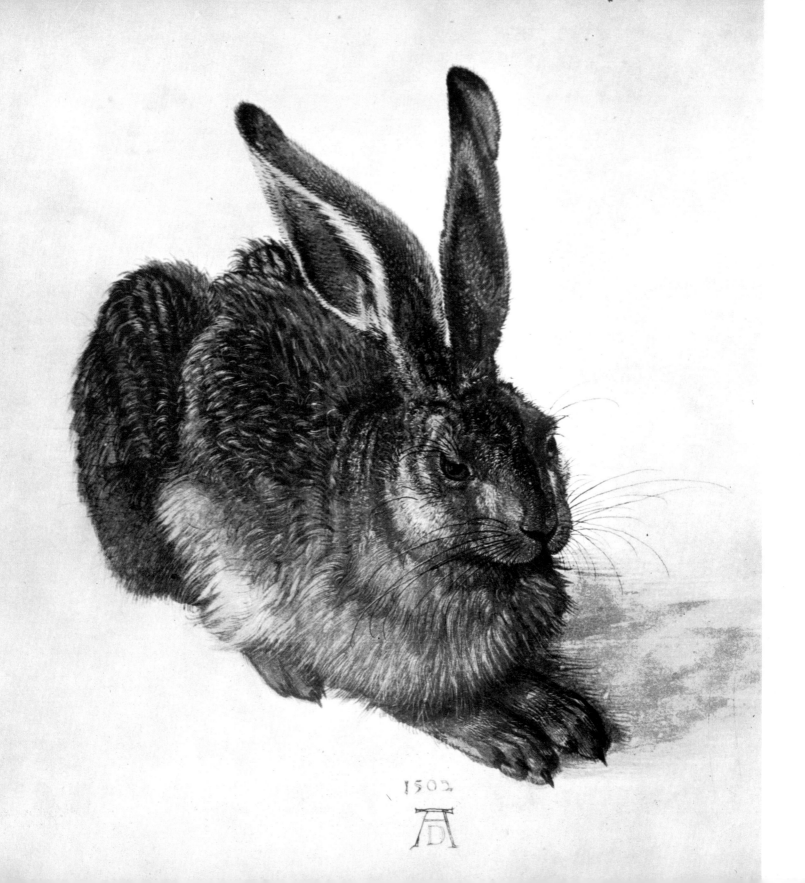

The hare (1502)
Watercolour and gouache

Albertina Museum
Vienna

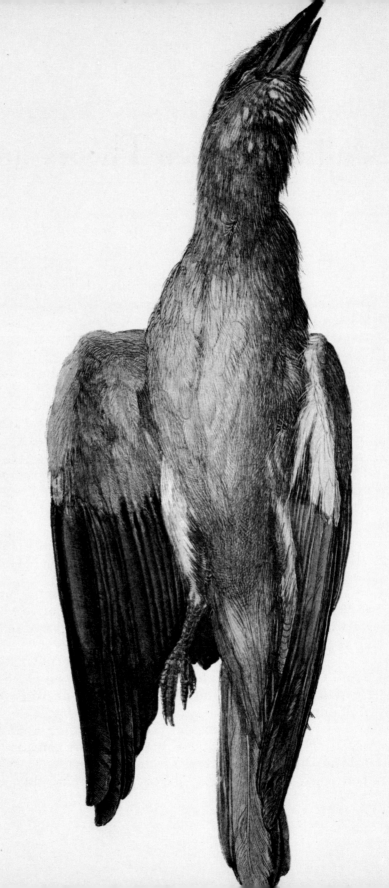

Study of a bird (1512)
Watercolour and gouache

Albertina Museum
Vienna

# The Conflict between Theory and Reality

The intellectual relations between Germany and Italy throughout history have been an absorbing and at the same time a tragic theme. Ludwig Curtius, the great specialist in the ancient world, has expressed it strikingly in his Memoirs — *Lebenserinnerungen* : "No people has been so well able as the German people, to give lustre to its spiritual kinship with Rome in a series of famous names."

Dürer said that he felt himself a lord only in Italy; Goethe, too, intoxicated by the Italian atmosphere was to exclaim, "I am only now beginning to live and to render homage to my genius."

Why did Dürer set off for Italy and what was he looking for? It is certain that the plague epidemic which devastated Nuremberg in 1494 was the direct cause of his departure. But unlike what he had done as a youth in 1490, no doubt like his father and Schongauer, he did not go to Alsace or Flanders. He looked further afield. His talks at Nuremberg with Pirckheimer and with other humanists encountered perhaps at Mainz, certainly at Basle, Strasbourg and Augsburg, had stimulated his curiosity, not only for the form but even more for the humanist content of the works of his Italian contemporaries.

Dürer had probably seen Italian engravings, among others those of Mantegna and Jacopo de' Barbari, before he left for Venice. His great friend Pirckheimer was then studying at Padua and nothing was more natural than to go and visit him.

Unfortunately we have no letter or document relating to this journey, which must have made an extraordinary impression on the mind of this young artist of 23. At Venice, "the Bride of the Sea", which even at that date already had a population of 100,000, Dürer must have become deeply steeped in the spirit of the Renaissance.

We can picture him admiring Verrocchio's Colleone, newly unveiled, and the works of Bellini and Carpaccio, with the paint hardly dry on them. He must have made contact with Giorgione's circle of friends, and the influence of the art of Lorenzo di Credi can still be recognized in Dürer's heads of children, highly personal in style as they are.

Many celebrated *Scuole*, including that of San Marco, many palaces and churches, had just been redecorated at the end of the last century. Giulio Campagnola was to include a portrait of Dürer in the frescoes of the Scuola dei Carmine at Padua. But Dürer wanted more than that; he was not satisfied with looking at the outside of things like a tourist. He wanted not only to see

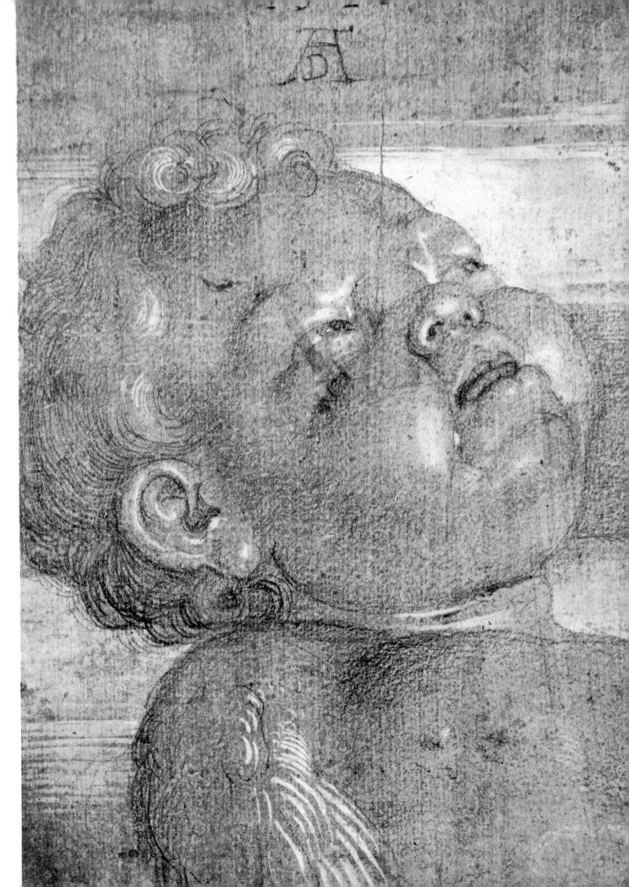

Head of an angel (1521)
Brush

Louvre, Paris

but, above all, to understand. He wanted to penetrate to the core hidden behind the appearances which nature offers us with infinite variety. With Dürer begins the search for the absolute, for the sole essential beauty, a quest for the secret laws which govern the ideal proportions so radically different from those of Gothic art. He is looking for a new measure and for new harmonies. In his last letter to Pirckheimer, dated 1506, Dürer writes that he still wants to go to Bologna, to learn, no doubt from Luca Pacioli, the secrets of perspective. We know that in 1505 he bought the edition, just off the press, of Euclid's Scientific Books.

He was therefore applying himself to the study of perspective and, above all, to the study of the proportions of the human body. He wanted to master and, for that purpose, to draw, the nude, that is to say, the figure in space, a classical subject if ever there was one. A magnificent example has come down to us, the female nude dated 1495 (in the Louvre), which is probably a study of a prostitute and recalls the drawings of Jacopo de' Barbari.

A little later the magnificent engravings appear in which nudes figure on the pretext of allegorical or mythological themes, the *Rape of Europa*, the *Large Fortune* and so many others, the finest of which is the *Adam and Eve* of 1504. Who can fail to recognize the Apollo Belvedere and the Medici Venus as well as the Vitruvian proportions?

Anyone who compares Dürer's later nude drawings with the Bayonne drawing (1493), so timidly gothic and much more a woman undressed than a woman nude, can see how much he learned from Mantegna.

But his nudes never attained perfect ease, they always retained an artificial element.

The many preparatory studies for the *Feast of the Rose Garlands* (National Gallery, Prague) and the *opus quinque dierum* (Thyssen collection, Lugano), painted shortly afterwards, perhaps at Rome, show that he never sacrificed the observation of nature and his Gothic heritage to classical theory.

Even in his later works he never renounces his cultural origins; it is a proof of Dürer's greatness that he was so well able to transmit the positive and essential qualities of his environment and his artistic heritage.

Furthermore, even the Italians could not escape the Gothic influence of medieval Germany, in the field of art any more than in the field of religion or politics. Did not Michaelangelo himself draw inspiration from Schongauer?

These opening years of the century form one of the most interesting periods in Dürer's life. Many studies in proportion, executed by him after long calculations with ruler and compasses after patient measurement and reflection, and modelled on Italian or classical works, did not succeed in convincing him completely.

Page from a sketchbook
of Dürer

Kupferstichkabinett
Berlin

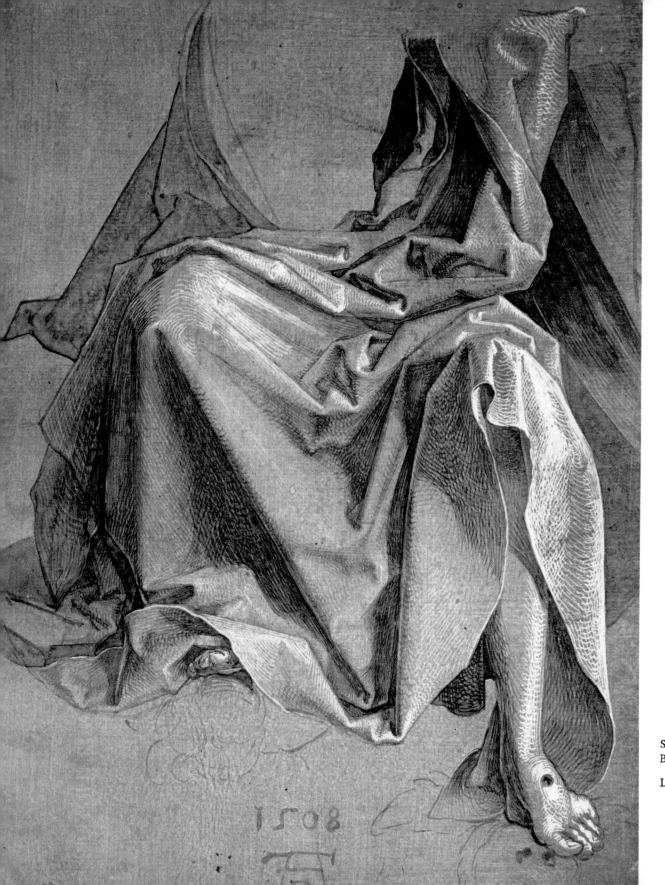

Study of Christ's mantle (1508)
Brush

Louvre, Paris

The ideal of beauty, of which he had drawn so many sketches around 1500, is already less predominant in the Prado *Adam and Eve* (about 1507). Setting off in search of universal principles, he is forced to admit that they are in disagreement with the visible reality which shows so many diversities, each of which may be harmonious in itself and even beautiful. Dürer then begins to doubt...

As we can see in the moving portrait of his mother, which dates from 1514, he recognizes that beauty does not depend on the model represented but in the last analysis on the genius of the artist himself. He notes: "Some have bad legs, others have crooked legs, and so each artist must be left free to choose what he wants to do. For it is a difficult master-stroke to transform vulgar things into a truly powerful art."

Dürer was more and more to recognize the relativity of his theories and to conclude that beauty and harmony are not something absolute, that the mind of man, an imperfect creature, is incapable of conceiving absolute and universal beauty. Relative beauty, on the contrary, depends on the harmonious equilibrium of the parts in relation to the whole. The relation differs for each subject, so that Dürer said, "between too much and too little there is a golden mean."

It is the role and the gift assigned to the artist to master the secoondary elements and to extract them from nature. To master these elements Dürer, as Wölfflin says, had to call to his aid his feeling for nature to keep alive the form he was seeking to fix. This impressive symbiosis of theory and practice forms one of the essential characteristics of his art and enables him to put into perspective his Italian contemporaries and his ideas of the 1500s. It is only today that, thanks to the conquests of modern art, we can move a little away from the image which romanticism has bequeathed us of him and judge how far his theories are essential. It has sometimes been said that without Italy he would never have become what he was; but should we regard that as a condemnation? Would Nicola Pisano have become one of the greatest sculptors of Italy of the first Renaissance if he had never been able to see the ancient statues of the Campo Santo?

The genius of great artists is that they never copy, but always retain their personal vision. Though Dürer gave proof of a real understanding of the ancient world, it never paralysed his creative power. His practical point of view as a craftsman, his observation and love of manual work finally merged in his work with theory and with what for him was beauty itself. It was to this synthesis that his encounter with Italy finally led Dürer.

If some people think that Italy "cured" Dürer of his Gothic origins, is it not because they are still influenced by the criticisms of Vasari and Dolce who, in the sixteenth century, regretted that Italy was not Durer's native land? But it is exactly by virtue of this symbiosis which he was able to achieve between North and South that fruitful ground was opened up to succeeding generations.

# The Journey to the Low Countries

In his admirable book, now a classic, Wölfflin writes that Dürer, already fifty, experienced during his visit to the Low Countries a renewal of his vision of the world, which has no parallel except in Rubens. The union of Rubens with his young and dearly loved second wife opened up new sources in him, deeper and richer than before. Dürer too seems to breathe a new air of youth during this journey.

The death in 1519 of the Emperor Maximilian, who had paid him a pension since 1512, as he did to so many other German artists, was the real cause of this journey, which Dürer made with his wife and their servant Suzanne. His object was to obtain the patronage and support of the new Emperor, Charles V. The travellers went by way of Bamberg and Vierzehnheiligen as far as Antwerp, which was then a very cosmopolitan town. Like Venice it maintained close relations with Nuremberg, some of whose businessmen, such as the Fuggers, the Tuchers, the Imhoffs or the Hirschvogels, had establishments in Antwerp. Dürer had set off with a great deal of luggage, taking with him, in addition to a selection of his own paintings and engravings, works by his colleagues Baldung Grien and Schäuffelein. He inteded to sell or exchange these pictures to pay his travelling expenses. We find in his travel journal, where he carefully noted his gains and his expenses, the names of the people he met and what he saw. The description of the welcome by the Guild of Antwerp, who received him with full ceremony on 15 August 1520, is particularly amusing: "And on Sunday, which was Saint Oswald's day, the painters of the town invited me with my wife and my servant to their Guild-hall. Everything was

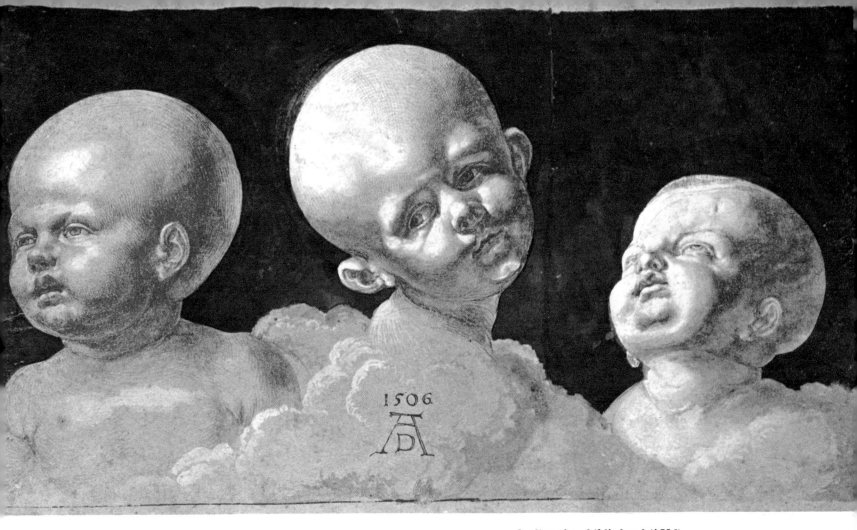

Studies of a child's head (1506)
Bibliothèque Nationale, Paris

decorated with silver or other precious ornaments and the dishes were delicious. Their wives were all there too. When they conducted me to my place at table everyone stood up on both sides as though they were receiving a great lord. There were some important people there, with well-known names, and they all bowed to salute me in the most courteous way. They assured me that they were ready to do their best to please me. When I was seated, the lord Horebouts, the town clerk of Antwerp, came up, followed by two attendants, and presented me with four flagons of wine on behalf of the lords of the town, adding that it was a mark of honour and a way of offering me their good wishes. I thanked them and tendered my good offices, very humbly. Then came Master Peter, the town carpenter, who in

turn presented me with two flagons of wine, with his good offices. We were all very gay together and late at night they accompanied us home by torchlight... "

There is no period in his life when Dürer seems closer to us than on this visit.

From Antwerp he visited Malines, Brussels and then Aachen, to attend the coronation festivities of the new Emperor. At Cologne, finally, he obtained the favours he expected from Charles V. Then he visited Bruges, where he saw Michaelangelo's statue, and Ghent, with the famous van Eyck altarpiece. He met a great many artists, including Quentin Massys, Patenir, Lucas van Leyden and Conrad Meit. At Brussels he admired the works of Roger van der Weyden and Hugo van der Goes. Their meticulous technique must have made a great impression on Dürer. Happily we can form an idea of this visit from some pen and ink drawings and twenty-seven silverpoint drawings, no doubt all that survives of a sketchbook. This period seems to have been particularly fruitful in drawings. The encounter with nature and reality charges his art with a new content.

In addition to the many portraits, the studies which he made during this visit for a painting of St Jerome (1521) can be numbered among the most impressive sheets which we possess from the hand of Dürer. The many drawings on a violet ground, of which the Albertina in Vienna has five examples, show the care with which he prepared his compositions. A magnificent study of a desk covered with books evokes in striking and moving fashion the studious atmosphere, the silent life which radiates from old texts and manuscripts, a world as dear to Saint Jerome as to his admirer Erasmus. It is perhaps one of the finest still lifes in European art. This sheet is completely realistic, executed in a very graphic style with white highlights added with the brush, but the composition never loses itself in useless details and retains an impressive rhythm.

Precision, rhythm, monumental character, are all found again in numerous studies by Dürer for a project he wanted to execute on his return. Why did he never execute this *Sacra Conversazione*? Probably the subject was too Catholic for the town of Nuremberg. But we have studies for the composition, in "shorthand", at Bayonne and in the Louvre. Studies for the figures of saints or for draperies, now in Berlin, Paris, London and Milan, give us an idea of what might have become a work of grandeur. The Virgins with Saints, which Dürer must have seen in the Low Countries, and the recollection of Bellini's famous altarpiece for the church of the Frari in Venice, may have given him the idea for this picture.

The visit to the Low Countries is therefore a particularly fruitful period for Dürer's art and yet we find from his journal that he was seriously troubled by religious difficulties. At Antwerp, where he met Erasmus and many humanists whose portraits he drew, Dürer was rightly worried about the future.

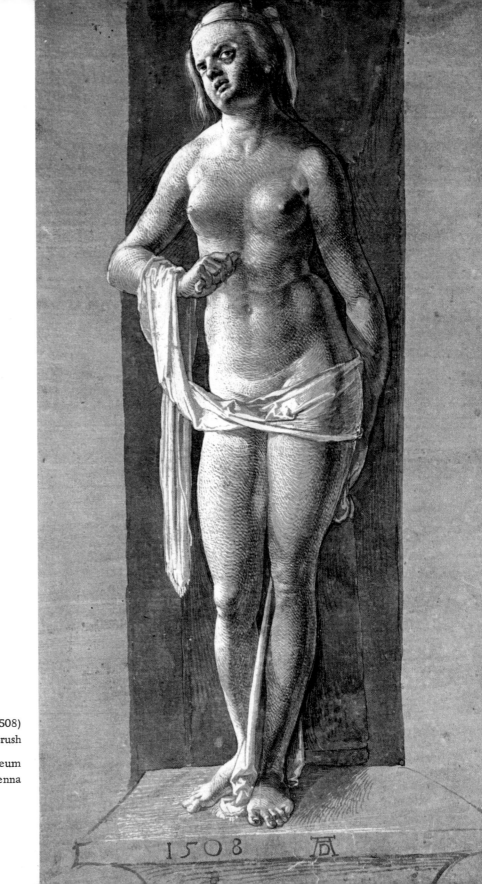

Lucretia (1508)
Brush

Albertina Museum
Vienna

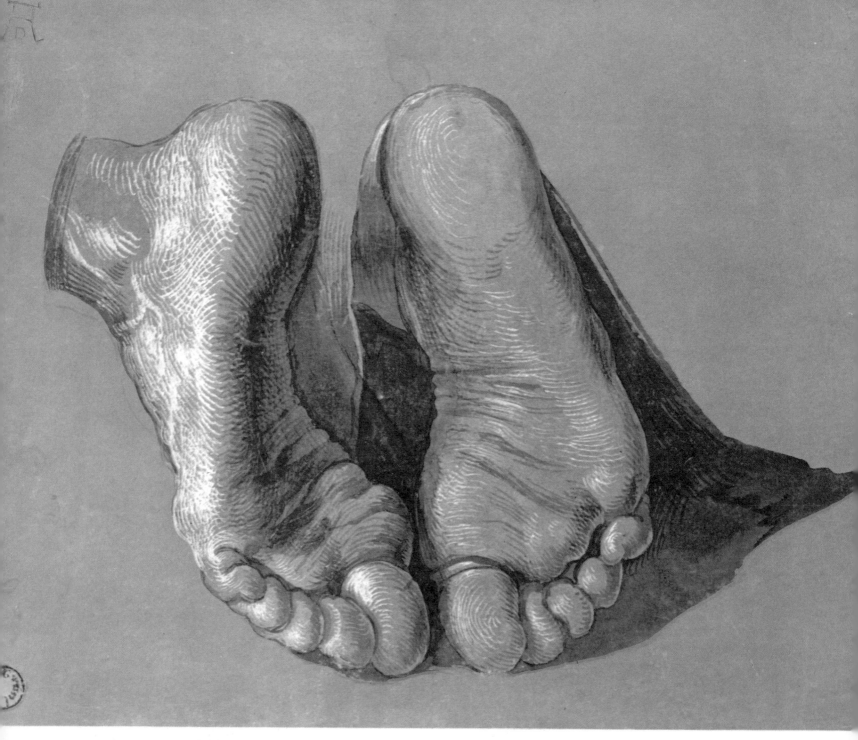

Study of the feet of an Apostle (1508)
Brush

Boymans Museum, Rotterdam

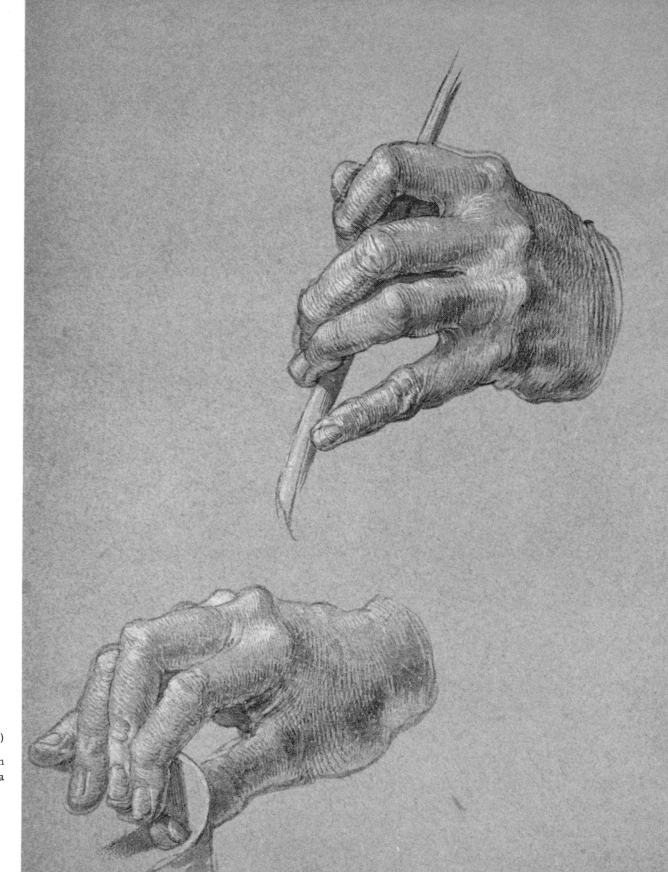

Study of hands (1505–1507)

Albertina Museum
Vienna

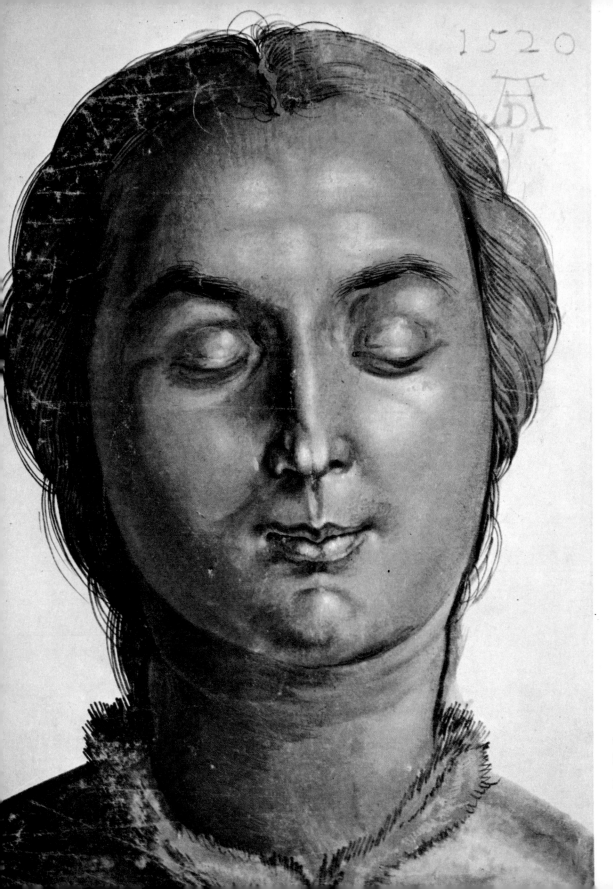

Woman's head (1520)
Brush

British Museum, London

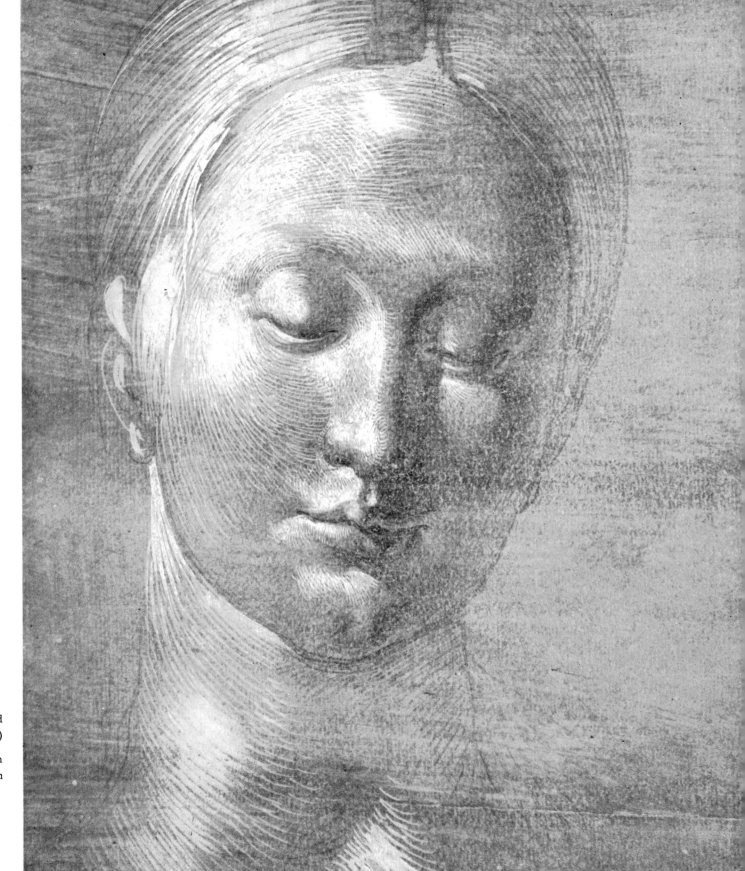

Woman's head
(1505)

British Museum
London

# Dürer, the committed Artist

**W**as Dürer merely an artist who observed the external world, trying to penetrate and understand it? Was he not something more? We know that his thirst for knowledge also induced him to write, that he sent and received a great many letters and met many of those who left their mark on his time — princes, scholars, statesmen and ecclesiastics.

But through his writings, drawings, engravings and paintings, he appears to us essentially as a profoundly religious man, who felt himself "concerned" by the events of his time.

We can already sense this intense personal commitment to the religious and political events of the day in the highly dramatic and mowing *Apocalipsis cum figuris*.

It is highly probable, and it has been maintained, that at the time when the Apocalypse appeared, not as a commissioned work but on the personal initiative of the artist, Dürer, who was then 26, was passing through an intense religious crisis. To this must be added the thought, common to many others, and particularly to Luther, that the end of the world was approaching. The same anguish had given cause for concern about the year 1000 — and do we ourselves dare to think beyond the year 2000?

Dürer tells us in his journal that in 1503 he had a vision; one day he saw innumerable crosses fall from the sky, one of them fell on to the clothing of a young girl, who became desperate, believing that she must die.

We find in Dürer's art and writings a reflection of the anguish which filled him, as it filled his contemporaries. Even more curious is the description he gives of a dream he had in 1525 and the meticulous drawing he made of this apocalyptic vision. It may be noted in this connection that whenever Dürer was a prey to violent emotion he felt the need to add an image to the written text.

He tells us how, in 1525, on the night after Whit Sunday, he saw, about four miles away from him, an incredible quantity of water fall from the sky and flood the whole earth.

In the Apocalypse, which was regarded as foretelling the coming of the Antichrist, it is written that celestial catastrophes will precede the deliverance and triumph of the heavenly Jerusalem. It is therefore not surprising that astrology should have had such a wide following at that

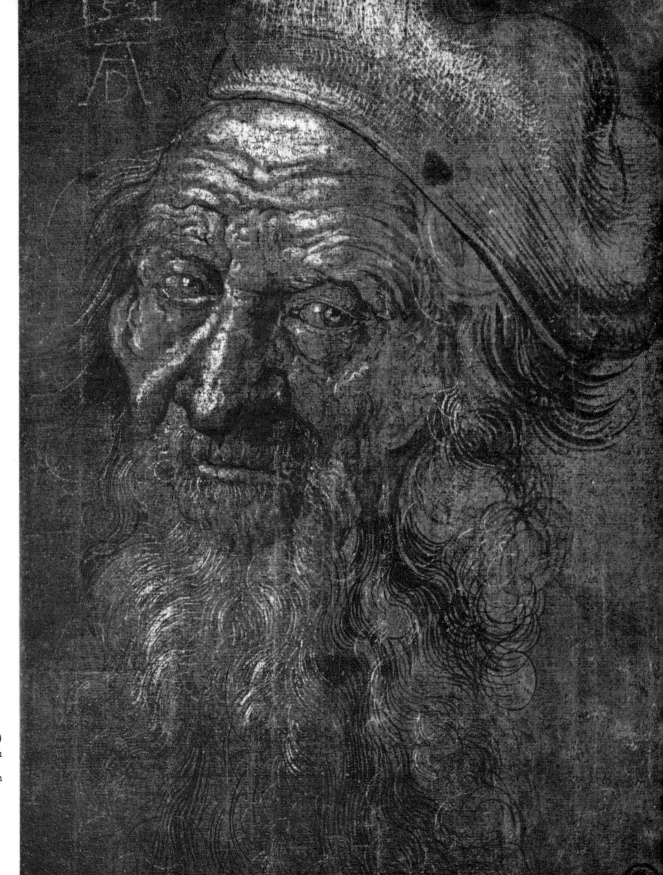

Head of an old man (1521)
Brush

Kupferstichkabinett, Berlin

1511

Mary and Jesus (1511)
Pen

Louvre, Paris

time and that celestial phenomena, such as the fall of a meteorite in 1492 or the birth of monsters or freaks, were regarded as warnings from heaven addressed to the Emperor or to Rome.

The woodcuts of the Apocalypse, like the marginal drawings (1515) for Maximilian's Prayerbook, of which the humanists, especially Erasmus and Celtis, expected so much, swarm with recriminatory allusions to the attitude of Pope Leo X or to certain unacceptable situations existing in the Roman Church. Even before Luther — twelve years younger than Dürer — appeared on the scene, Dürer's opposition to Rome is already clearly evident. He also seems to have been involved in the appearance of a number of pamphlets — the political journalism of the day.

His art assumes a very marked topical character, which is not without influence on the style he adopted.

The elegant mannerism of the last days of Gothic, so dear to Schongauer and to Dürer in his early days, disappears thanks to the contacts of the artist with the Italians, but also because his art itself changes its content and thereby his role in society changes too.

Dürer must have sympathized deeply with Luther's ideas. The Dutch painter Scorel, who visited him in 1519 on his way to Rome, recounts that he was absorbed in reading Luther's sermons, which were then shaking the world. Perhaps the most striking thing is Dürer's spontaneous reaction on learning the news — which proved to be false — of Luther's death after the Diet of Worms. He wrote these words in his journal in 1521, while he was travelling in the Low Countries : "He was a disciple of Christ and of the true belief. Is he still living or have they assassinated him? I know nothing. He has suffered that for the true Faith and because he condemned the pagan Papacy."

Shortly afterwards, Dürer was to call upon Erasmus — whom he had recently met at Antwerp and Brussels — to take Luther's place and thus acquire the martyr's crown, an honour to which Erasmus in no way aspired.

"Oh, Erasmus of Rotterdam, what wilt thou do? Thou seest how unjust tyranny introduces into the world violence and the reign of darkness! Hear, Knight of Christ, advance, take thy place at the side of the Lord, to uphold the truth and win the marty's crown!"

It was Luther's personal and authentic conviction which attracted Dürer. Like many of his contemporaries, he was less and less satisfied by the official doctrines and dogma of the Church. This religious attitude coincides with the doubts and scepticism which he feels rising in him about the rules of absolute beauty; in his personal conception of beauty we find something of this fundamental doubt.

The dramatic intensity of the *Passion of Christ* (1520-4) immediately makes us sensible of Dürer's burning religious conviction.

The artist has magnificently expressed, in a pen and ink drawing, the moment when Jesus entreats his Father to let the cup pass from him. As with Mantegna, Christ is lying on the

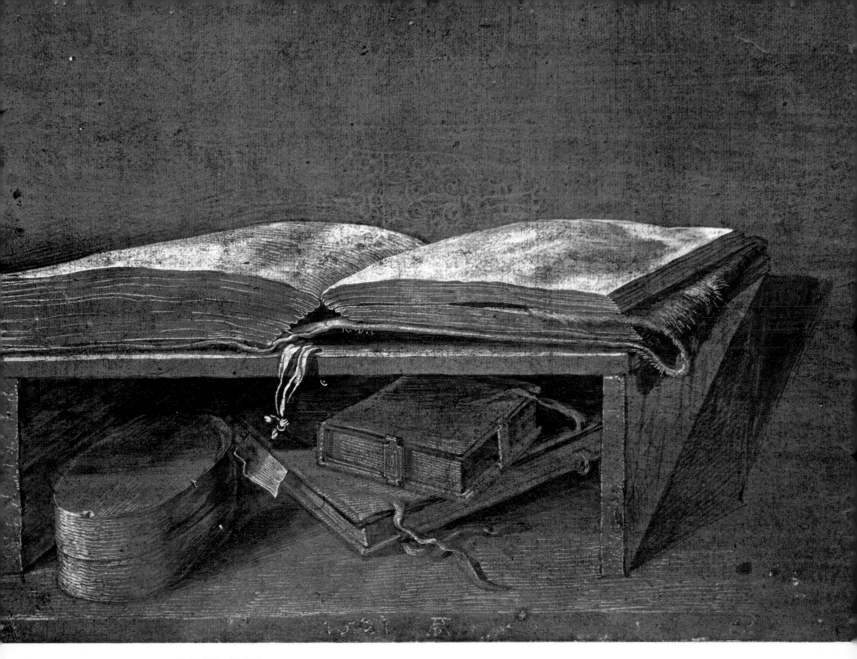

Still Life (1521)
Brush

Albertina Museum, Vienna

ground, while an angel appears to him in a cloud. Dürer has had the skill, by an austere composition, to combine grandeur with an extreme dramatic effect.

We find the same feeling in the *Descent from the Cross* of 1522 (formerly at Bremen), powerfully drawn in silverpoint. Jakob Rosenberg writes in this connection : "Here he is both expressionist and classical. He rivals Grünewald in intensity of emotional power, but nevertheless conserves his self-mastery and dignity, the grandeur and clarity which he had attained after trying for a long time to adapt his own style to the acquisitions of the Italian Renaissance."

We see to what extent Dürer, in his years of maturity (1521-3) stressed expressionism of the human figure. The *St Mary Magdalene* — an impressive drawing of 1523 — and the monumental sheet representing *Mary and the Holy Women* (Louvre) bear witness to the same spirit. They are the studies for an engraving which Dürer executed after his return from the Low Countries.

Though he visibly sympathized with the most orthodox Lutheranism, Dürer never associated himself with any reform movement. He must very soon have recognized the extreme division and intolerance which reigned in the different sects. He clearly expressed his opinion on this in his last great painting, known as *The Four Apostles* (1526) (today in the Bayerische Staatsgemälde-sammlung at Munich). Four texts, attributed to each of the four Saints, are to be found in an inscription sometimes called "Dürer's Testament" (this inscription is not by Dürer and is today in Nuremberg, separated from the painting). These texts warn the city of Nuremberg, which had just renounced its obedience to the Pope and associated itself with the new faith (1525), against false prophets, that is to say, against the Catholic Church, but also against the innumerable sects and reformers who were harming the unity of the Reformation.

Three magnificent pencil drawings, preparatory studies for this painting (today in Bayonne and Berlin), give us an idea of the highly noble and monumental character of Dürer's last drawings.

The head of St Mark the Evangelist, on paper prepared in brown, is particularly impressive. The drawing is a fascinating play of calligraphic lines, which recall his youthful works, with a sentimental content which already foreshadows mannerism.

For us, who are four-and-a-half centuries younger, is there not an evident parallel here with our own time?

For us, too, the standards and outlook of the past have disappeared or are under challenge. We, too, must revise our faith in art, ethics, morals, education and religion. Is not our contact with reality also threatened with disappearance, undermined by the adulterated expression of feelings, by a commitment tinged with snobbery, by the commercialization of art and by false prophets?

# The Man

The more we know about a person, the harder it is to form a complete picture of his personality.  This is true for our own circle and it is equally true for historical figures in general.

That we can know Dürer through his art, as his friend Melanchthon said, is only partly true.  In addition to his drawings engravings and paintings, we have a number of his letters, poems, writings on questions of aesthetics, the journal of his travels in the Low Countries, his family chronicle and, naturally, comments given by his contemporaries and many other documents as well.

From these texts we may conclude that Dürer had a particularly complex personality.  To this must be added the fact that it is almost impossible for us to re-create the feelings of the past, of a time when the fatal separation between civilization and erudition did not yet exist, a time when science and art, instinct and reason, could associate together in a way which we can hardly imagine.

Dürer must have been a handsome and very remarkable man.  His face was long, his brow lofty, with carefully tended curly hair framing his face to the shoulders.  Beneath a slightly aquiline nose, his mouth was full and sensual.  His portraits look out upon us with sombre eyes and a grave, critical and intelligent look.  He cannot have been very tall; his movements were of an almost aristocratic deliberation, his hands long and expressive. Like his friend Pirckheimer, he enjoyed sport; we know that he was a swordsman and that he liked music, women and dancing.  According to his contemporaries he was a gentle, pleasant man, with great *savoir-vivre*.  Although his travel journal in the Low Countries — it is more like an account book — shows us that he was sometimes careful and precise, almost to the point of scruple, in money matters, we know that he could be generous and even liberal, particularly when it came to giving away his own works.

Portrait of Erasmus (1521)
Black chalk

Louvre, Paris

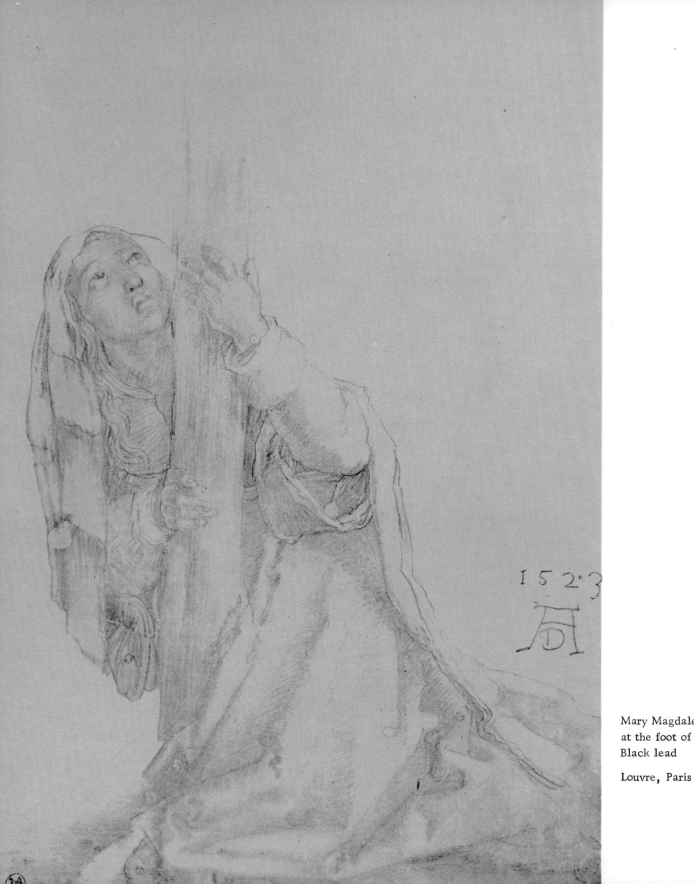

1 5 2 3

Mary Magdalene
at the foot of the Cross (1523)
Black lead

Louvre, Paris

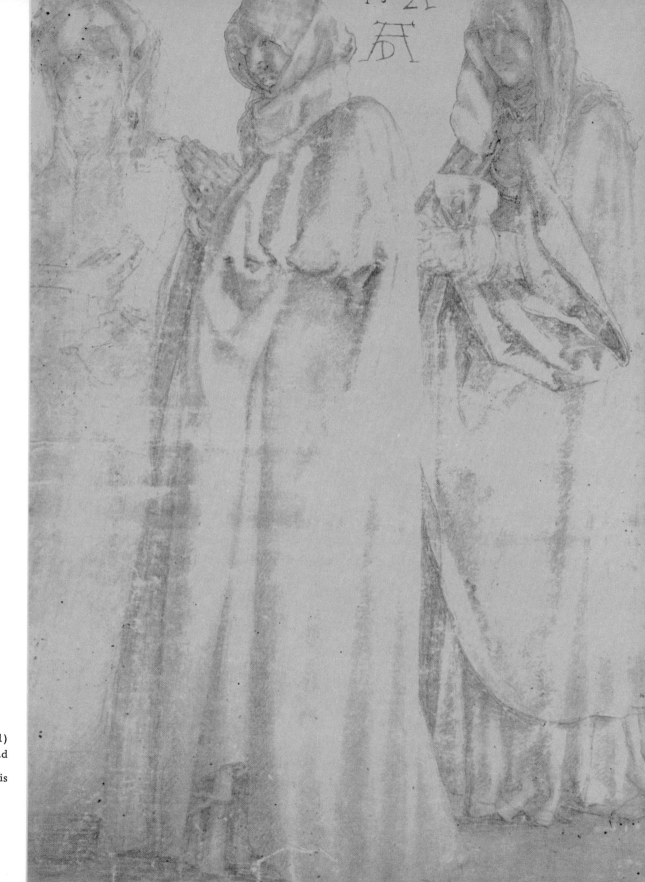

Mary and the Holy Women (1521)

Black lead

Louvre, Paris

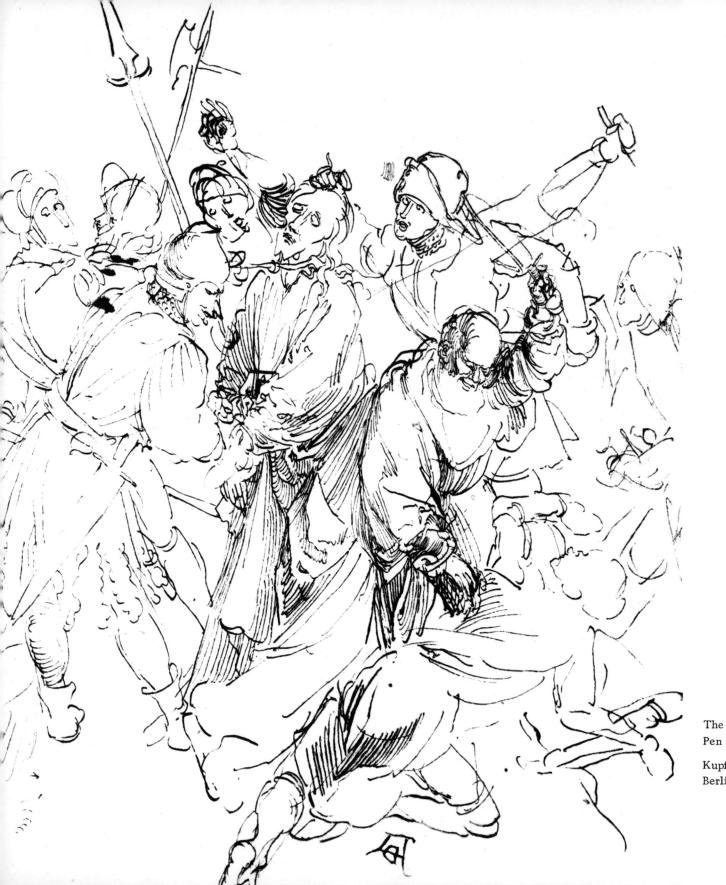

The arrest of Christ
Pen

Kupferstichkabinett
Berlin

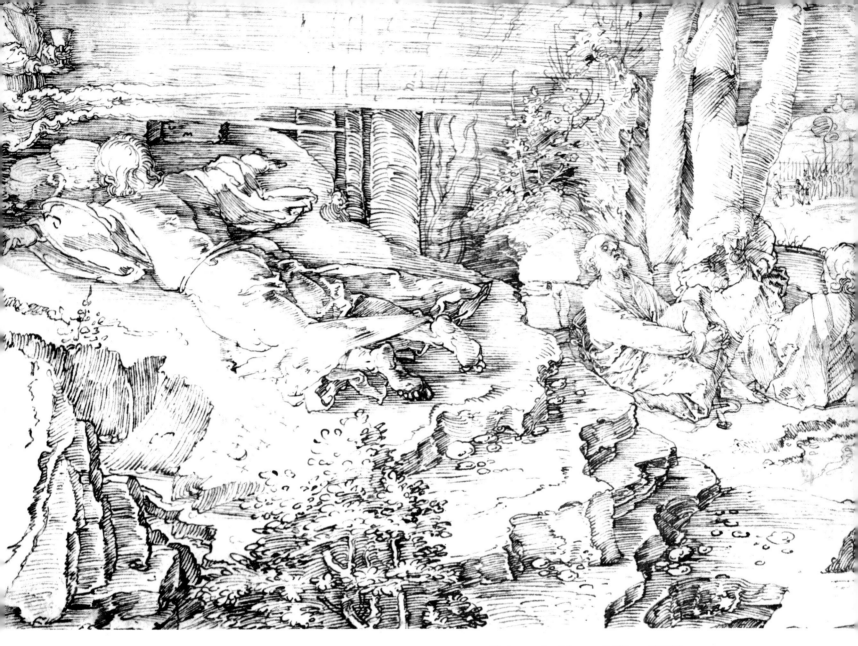

Christ on the Mount of Olives (1521)
Pen

Städelsches Kunstinstitut, Frankfurt

Towards his parents he showed himself a dutiful son, almost movingly so. He was careful of his appearance, dressed well and visibly took great pleasure in finding himself in the company of important or highly-born people and in being treated as a *gentiluomo*. During his visits to Italy and Flanders he was received by scholars, princes, bishops, bankers and other important figures. Dürer himself was a poet and a scholar as well as an artist. He had, for example, an animated correspondence with the astronomer Kratzer on the mathematics of Euclid.

Beyond doubt, he was thoroughly familiar with the works of Erasmus, the Bible and the writings of Luther.

Even when he handles traditional themes such as the Apocalypse, he knows how to give them a highly original form and spiritual content, because he is sensitive to the spirit of his time and to the thoughts which animate the Reformation, without ever losing contact with nature.

Like so many great artists — like Rembrandt, Rubens, Delacroix, Picasso — Dürer had infinitely sensitive antennae for recognizing anything which had artistic value or a quality of interest. He immediately felt the greatness of the Flemish masters, of Schonguaer and his circle, as well as of his Italian contemporaries, and especially Mantegna, and he was able to make a particularly happy fusion of them. In his youthful studies, after Mantegna, he rediscovers, thanks to a personal script, the sculptural and severe character and the disconcerting certainty of the Italian. And, because he looked at it with a new eye, Dürer learned to see in Italian art not only the classical beauty and harmony of the human body, but even more the emotional values which infuse the work of a Pollaiuolo, of a Mantegna and, above all, of a Bellini.

Even more, he very soon understood the spirit of Antiquity without, so far as we know, ever having seen ancient statues or reliefs. And yet, writes Panofsky, his interpretations were often more penetrated with the spirit of the ancients than his Italian models.

In quite a different sphere, he immediately felt the value of new processes of expression and foresaw the importance which would be assumed by printing and engraving.

An excellent business man, he was not only the author, but also the publisher, of his engraved work. Vasarely remarks that his plates represent the start of the epoch of the generous distribution of works of art.

How fascinating it would have been to talk with Dürer! No doubt we can form some idea of his face and his character, but his profound thought on the process of artistic creation is even more fascinating.

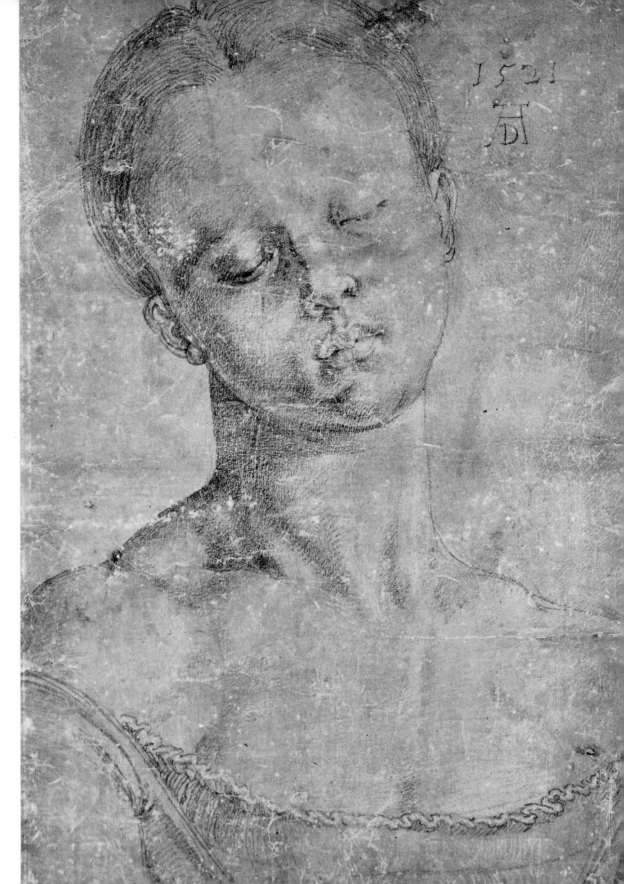

Saint Barbara (1521)
Black lead

Louvre, Paris

# The Artist

Jean Sabartès has written that, for Picasso, art is a consequence of sadness and suffering. One teaches us to meditate and the other is the whole foundation of life.

We find the same idea in Dürer, too. Has not Aristotle, the pupil of Plato, also observed that all those who distinguish themselves in the field of philosophy, politics, poetry and the other arts are melancholics, born under the sign of Saturn? This idea was very popular during the Renaissance, thanks to the neo-Platonist philosopher Ficino, and it may possibly have reached Dürer through Agrippa von Nettesheim.

His writings and works give us the impression that he was in the habit of introspection. Melanchthon tells us that Dürer was a malancholic and praises *"melancholia generosissima Dureris"*. He looked upon himself not as a craftsman, as we can see from his portraits, but as an artist favoured by the Divine creative grace, like his contemporary Michaelangelo. In him, moments of creative impulse alternated with periods of melancholy, a feeling of imperfection, void, depression.

His almost metaphysical and religious search for an ideal of absolute beauty, and the relative idea of it which he was finally to form, join hands with the fundamentally tragic concept of the humanists of his time, who understood that man is an imperfect and fragile creature. But as Pico della Mirandola had already pointed out in 1486, in his famous *De hominis dignitate*, it is precisely in this imperfection that the special dignity of man lies. At the very time when Dürer was composing the *Apocalypse*, he wrote: "Our understanding is all lies, and obscurity is so firmly anchored in our minds that even our best efforts are doomed to failure... Incapable of attaining the best, must we therefore abandon the search? We cannot accept this redoubtable thought, for even if man lives in the prospect of encountering good and evil, it is fitting that a reasonable being should concentrate on the good."

We know that Dürer had personally experienced the paralysing effect of melancholic depressions. Something of them can be felt in a number of his portraits, especially in a magnificent study of an old man with a beard and above all in the face of the Apostle Paul in *The Four Apostles*.

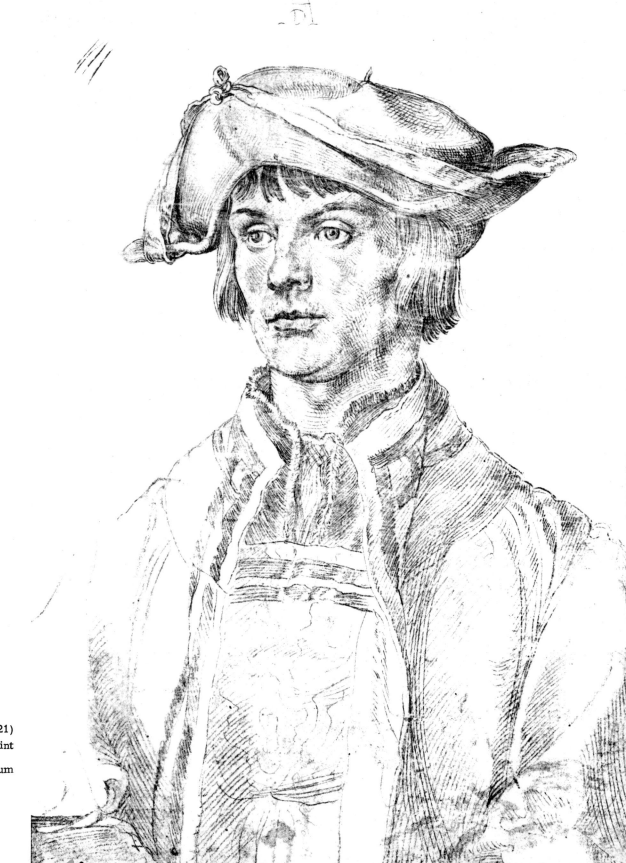

Lucas van Leyden (1521)
Silverpoint

Lille Museum

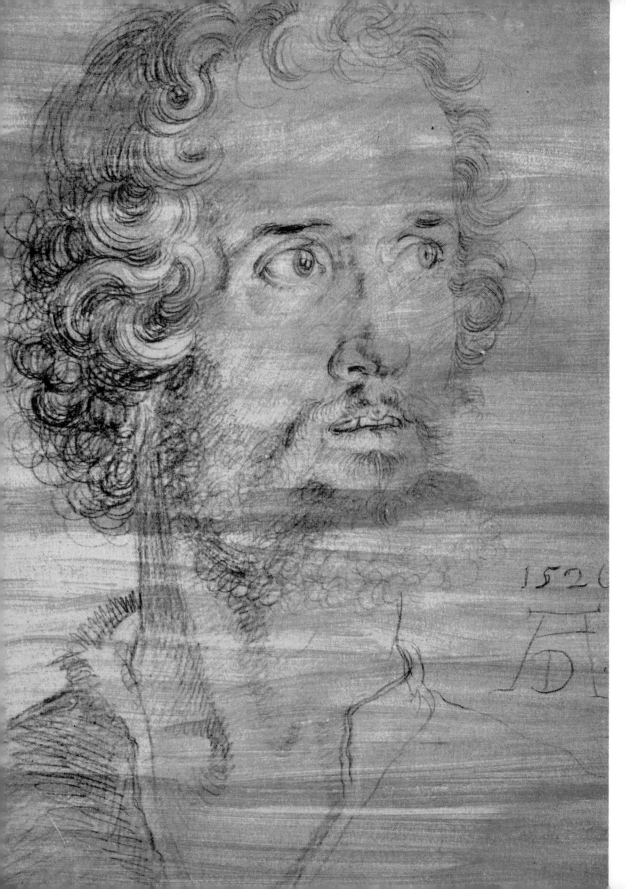

Head of Saint Mark (1520)
Kupferstichkabinett, Berlin

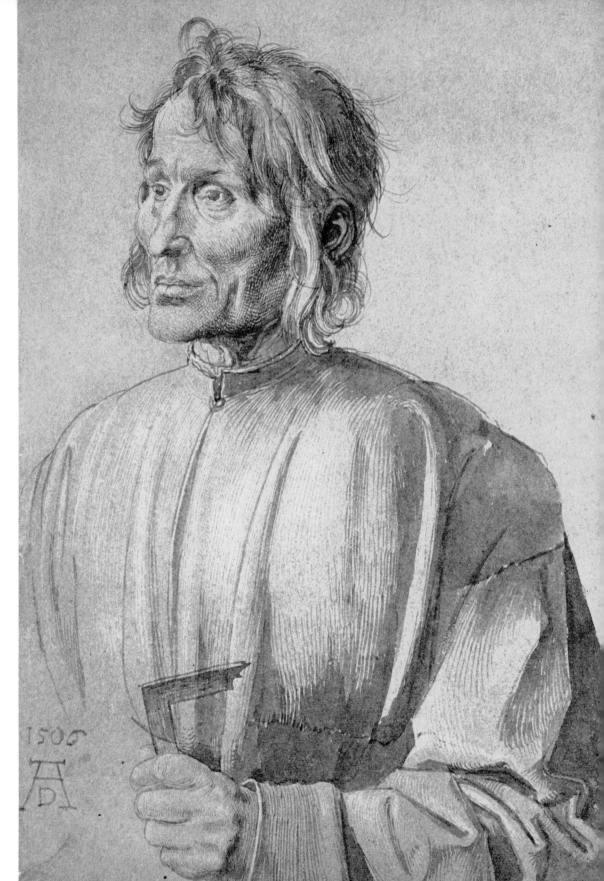

Portrait of an architect (1506)
Brush

Kupferstichkabinett, Berlin

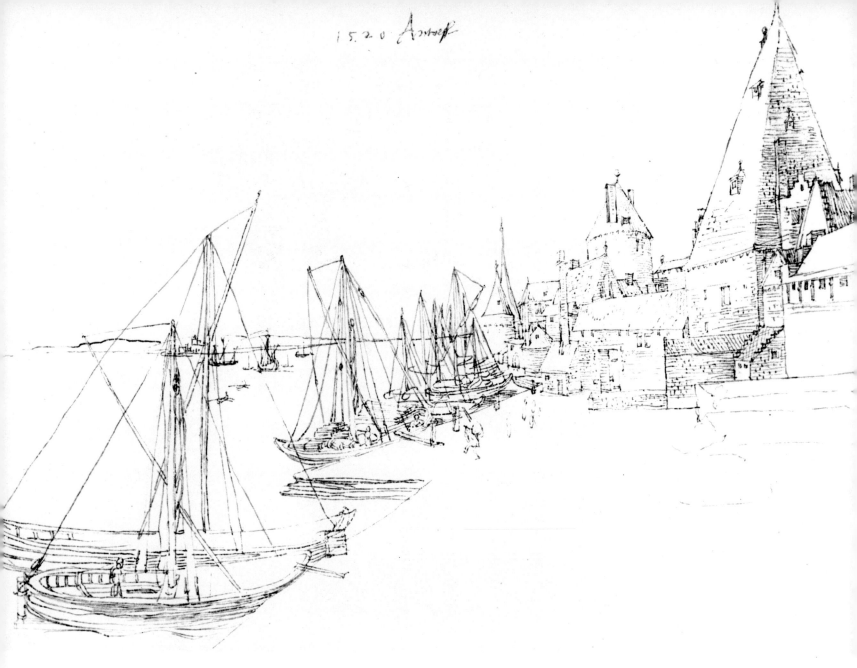

The port of Antwerp (1520)
Pen

Albertina Museum, Vienna

He gave expression, both grandiose and profound, to his thoughts on this subject in the famous engraving of 1514, *Melancolia*; according to Walter Pater, this engraving, in its power of suggestion can be compared only to Leonardo's Mona Lisa. In this evocation which "astounds the world" (Vasari) he expresses his conception of man, an imperfect creature, incapable of attaining to the divine knowledge. This image, of which only a few studies are known, is as topical today as it was in Dürer's time. It is, in sum, a confession of impotence, the expression of a painful doubt of the possibilities of man and of his creative power.

Every artist experiences it; there is no form or language which can express what he perceives, the "new reality" which he creates is only one of the many possibilities open. The profound verity no man can express, and as de Vigny said: "Silence alone is great, all the rest is weakness."

# Dürer and Us

If we desire, as spectators, to draw a lesson and an encouragement from "the Universe of Dürer", the first thing we must do is to go and see his works and realize, on turning over the reproductions, that however beautiful they are, they are merely a reference to the original reality. Is that not all that matters? If our sensitivity to the original falters, we are then in danger of falling into a pseudo-culture, which no longer has anything in common with the living dialogue which should be established between the work of art and its admirer. For it is exactly in this exchange that the work of art finds its reason for existence.

In this dialogue, the spectator then finds himself completely solitary, as the artist was in his dialogue with reality, or to use the words of Matisse: "In art, anything which can be expressed in words does not count."

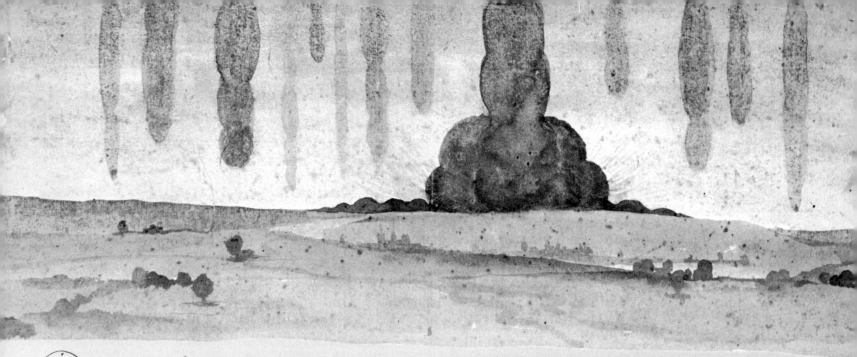

Im 1525 Jor noch dem pfingstag zwischen dem ~~pfin~~ mitwoch und pfintztag Jn der nacht Jm schlaff hab Jch dis gesicht gesehen wÿ fill grosser wassern vom himell fillen Vnd das erst traff das ertrich vngeferlich 4 meill fon mir mit einer sölchen grausomkeit mit eynem übergrossen rauschen vnd zersprützen vnd ertrenket das gantz lant Jn sölchem erschrack Jch so gar schrocklich das Jch daran erwachet Ee dy andern wasser fillen Vnd dy wasser dy do fillen dy woren fast groß vnd der fill ettliche weit ettliche neher vnd sÿ komen so hoch herab das sy Jm gedunken gleich longsam fillen. aber do das erst wasser das das ertrich traff schir herbeÿ kom do fill es mit einer sölchen geschwindikeit wint vnd brausen das Jch also erschrack do Jch erwacht das mir all mein leichnam zittert vnd long nit recht zu mir selbs kom Aber do Jch am morgen auff stund molet Jch sy oben bÿ Jetz geschriben hett. Got wende alle ding zw besten

Albrecht dürer

Vision in a dream (1526)
Watercolour

Kunsthistorisches Museum, Vienna